Tom Wesselmann

Tom

Wesselmann

CHARTA

Progetto grafico/Design
Gabriele Nason

Coordinamento redazionale/Editorial Coordination
Emanuela Belloni, Elena Carotti

Redazione/Editing
Cecilia Bagnoli, Charles Gute

Traduzioni/Translations
Marcella Rivatelli, Simon Turner

Copy e Ufficio stampa/Copywriting and Press Office
Silvia Palombi Arte&Mostre, Milano

*Grafica Web e promozione on-line/Web Design
and On-line Promotion*
Barbara Bonacina

p. 2
Tom Wesselmann, ca. 1992

Copertina/Cover
Sunset Nude, Yellow Tulips, Yellow Curtain, 2003

Crediti fotografici/Photo credits
Jerry Goodman
Jim Strong
Jeffrey Sturges

Ci scusiamo se per cause indipendenti dalla nostra volontà
abbiamo omesso alcune referenze fotografiche.
We apologize if, due to reasons wholly beyond our control,
some of the photo sources have not been listed.

Edizioni Charta
via della Moscova, 27
20121 Milano
Tel. +39-026598098/026598200
Fax +39-026598577
e-mail: edcharta@tin.it
www.chartaartbooks.it

Printed in Italy

Flora Bigai Arte Moderna e Contemporanea

San Marco 1652, Venezia
Tel. +39 0415212208-0412413799
Fax +39 0412960098

via Garibaldi 22, Pietrasanta (Lucca)
Tel.+39 0584792635
Fax +39 0584792459

e-mail: flora.bigai@iol.it
www.florabigai.com

Tom Wesselmann

Flora Bigai Arte Moderna e Contemporanea, Venezia
14 giugno-31 ottobre 2003
June 14-October 31, 2003

Flora Bigai Arte Moderna e Contemporanea, Pietrasanta
26 luglio-31 agosto 2003
July 26-August 31, 2003

Un particolare ringraziamento alla Robert Miller Gallery
di New York che ha reso possibile la realizzazione di questa mostra.

A special thanks to the Robert Miller Gallery, New York,
which made the organization of this exhibition possible.

Sommario/Contents

Tom Wesselmann

Danilo Eccher

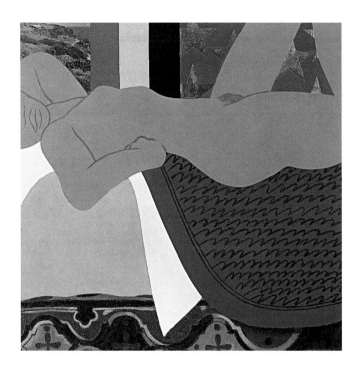

Great American Nude #1, *1961*

Riflettere sull'opera di Tom Wesselmann significa affrontare l'analisi di una delle più significative avventure dell'arte contemporanea: quella che, a partire dagli anni Sessanta, ha riconsiderato la centralità di un processo narrativo che pareva destinato ad arenarsi in una marginalità autoreferente. Sono gli anni di una prepotente dissolvenza iconica che sbiadisce e svapora ogni immagine, allontanando dal palcoscenico pittorico l'idea stessa di racconto. La figura appare sempre più come la "zattera della medusa" di Géricault, dove un disperato drappello di folli è ormai abbandonato al proprio tragico destino tra i flutti. E ciò in un contesto in cui l'impianto narrativo è identificato come volto sentimentale di un processo emotivo che articola la propria grammatica nelle figure fantastiche di una psicologia letteraria e sofisticatamente poetica. Ma proprio questo incanto evocativo in realtà allontana la traccia iconica dal suo contesto rappresentativo, riducendone spesso la magia espressiva a un esercizio virtuosistico di colta cosmesi linguistica. In non pochi casi tale processo propone pagine di altissima lirica pittorica – basti pensare a Bacon o a Giacometti – dove il sospeso e sofferente senso di malattia non tradisce la complessità di un linguaggio per nulla arreso alla compiacenza di un facile coinvolgimento. Una malattia urlata e violenta, oppure silenziosamente corrosiva, traccia un racconto sfuggente, dove l'immagine riesce comunque a manifestarsi oltre la sfera della suggestione e del dramma. Eppure lo spostamento dell'asse di ricerca sul piano dell'analisi linguistica aveva ridistribuito i pesi interpretativi, imponendo alla figura una recitazione più ombrosa, più magicamente distaccata, più liturgicamente elevata, ma proprio perciò distante.

Ecco allora che la comparsa di un nuovo vocabolario rappresentativo, scollegato dalle suggestioni psicologiche ma, all'opposto, direttamente espressione di un racconto quotidiano e popolare, ha rappresentato un assoluto capovolgimento di

ottica, contribuendo a definire una prospettiva che ancora oggi presenta sorprendenti aspetti di attualità. In questo modo la figura scardina l'estasi poetica di un racconto emozionale per riflettere una realtà visiva dalla dirompente forza comunicativa. Si afferma cioè un processo narrativo che si rivolge alla prassi del linguaggio, piuttosto che alle sollecitazioni del racconto, che guida quindi lo sguardo sul versante formale e compositivo, distogliendo l'attenzione dall'oggetto significante. Ma tale processo narrativo – cosa forse decisiva e comunque determinante – rielabora la scala dei valori invertendone il vertice e la base e attribuendo proprio al linguaggio formale, all'immagine, il posto più elevato. Non solo, dunque, una semplice sostituzione dell'oggetto di ricerca, ma il riconoscimento di un protagonismo artistico al linguaggio in sé, al suo valore significante primario, alla rappresentazione che compone il suo stesso oggetto. Allora l'immagine può essere serialmente riprodotta per offuscare l'intensità del racconto e, proprio nella ripetizione, enfatizzare la sua struttura esterna; allo stesso modo può ingigantire, sostituire o fedelmente riprodurre l'oggettistica quotidiana per reclamare la forza della propria presenza. Come in Duchamp, la scelta dell'artista rappresenta l'opera: non l'oggetto, non l'immagine, ma proprio l'incontinenza estetica di scegliere quell'oggetto e quell'immagine.

Uno straordinario protagonista di questa importante pagina della storia dell'arte contemporanea è sicuramente Tom Wesselmann, che ha saputo coniugare una sorprendente personalità formale e una raffinata cultura pittorica, dimostrando non solo la prontezza concettuale nel riconoscere i fermenti di una nuova creatività, ma anche un'acuta e sensibile cultura pittorica. Ciò è ampiamente riconoscibile nei primi grandi collage realizzati sul finire degli anni Cinquanta dove, pur nella prospettiva dello "strappo" – che più o meno negli stessi anni vede protagonista anche Mimmo Rotella – si riconosce la visiona-

Tom Wesselmann

Danilo Eccher

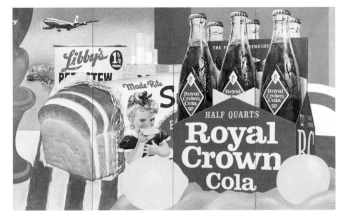

Still Life #35, *1963*

An examination of Tom Wesselmann's works requires an analysis of one of the most significant adventures in contemporary art. It is one that, since the 1960s, has reconsidered the central role of the narrative process, which appeared at that time to have run aground in self-celebratory marginalization.

Those were the years of an overwhelming iconographic dissolution that made every image fade and disappear, removing the very idea of narrative from the theater of painting. Figures increasingly recalled Géricault's *Raft of the Medusa*, in which a desperate band of crazed people is abandoned to their own tragic destiny on the waves. In a context in which the narrative structure can be seen to be the sentimental façade of an emotional process that expresses its own grammar in the fantastic figures of a literary and sophisticatedly poetic psychology. But it is precisely this fascinating enchantment that actually removes the iconic concept from its representational context, often reducing the expressive magic to no more than a virtuoso exercise in cultured linguistic cosmesis. Very often this process offers us pages of extraordinary pictorial lyricism: one need only think of Bacon or Giacometti, in which the suspended and painful sense of disease does not betray the complexity of a language that has by no means given in to the self-satisfaction of facile participation. A disease that is screamed out and violent, or silently corrosive as it traces out an elusive tale, in which the image always manages to appear beyond the sphere of emotion and drama. And yet this shift of approach to study in the field of linguistic analysis had redistributed the weight of interpretation, giving the figure its shadier role, more magically detached, more liturgically elevated, but precisely for this reason more distant.

So here we have the emergence of a new vocabulary of representation, detached from psychological influences but, on the contrary, the direct expression of an everyday and popular story. It turned the viewpoint on its head and helped define a perspective that even today is most extraordinarily topical. The figure thus breaks down the poetic ecstasy of an emotional tale to reflect on a visual reality of sensational communicative power. In other words, a narrative process was established that turned to the processes of language rather than to the demands of the narrative, guiding the eye towards formal and compositional aspects and turning attention away from the referent object. But a significant, possibly decisive aspect is that it redrafts the scale of values, turning it the other way up, and giving formal language and image a place at the very top. So it is not merely a substitution of the object of study, but the recognition of artistic protagonism in language itself, in its primary signifying value, in the representation that composes its own object. So the image can be mass-produced to conceal the intensity of the narrative and, in this very repetition, emphasize its own external structure. At the same time, it can enlarge, replace or faithfully reproduce the objects of our everyday lives to reclaim the power of its own presence. As in Duchamp, the artist's choice is the work, not the object, not the image, but precisely the aesthetic incontinence of choosing that particular object, that particular image.

An extraordinary protagonist of this important chapter in the history of contemporary art is certainly Tom Wesselmann, who has been able to combine a powerful formal personality with an elegant pictorial culture. He has demonstrated not only conceptual promptitude in recognizing the turmoil of a new form of creativity, but has also proved to have a keen and sensitive culture of painting. This can be clearly seen in the early large collages that he made towards the end of the fifties. Here, even though in the context of

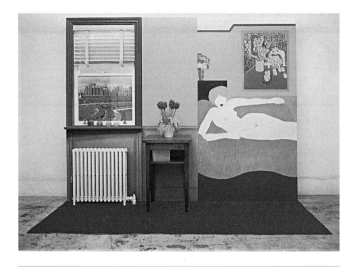

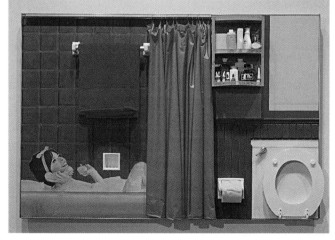

rietà rapsodica di Kurt Schwitters. Anche nei più piccoli collage di qualche anno dopo, l'atmosfera eccitata di una sperimentazione estrema e insoddisfatta si stempera nella definizione del dettaglio decorativo, quella invadente e proliferante carta da parati che, come nei quadri di Vuillard, avvolge l'immagine soffocandola in un racconto caotico ed eccitante. Come nel magazzino di un rigattiere gli oggetti si accatastano, intrecciandosi e confondendosi, le immagini e le forme di questi collage anticipano formalmente quella concentrazione sul dettaglio e sulla narrazione sincopata che poi costituirà l'asse portante dell'arte di Wesselmann. Un'anticipazione che si riconoscerà soprattutto nei *Collage Paintings* dei primi anni Sessanta, dove le intuizioni degli anni precedenti si dispiegano in tutta la loro prepotente innovazione linguistica.

Sono le opere della serie *Still Life*, in cui l'impianto narrativo ha definitivamente riconosciuto il ruolo di un'immagine popolare non solo nel processo di comunicazione, ma anche in quello di definizione del gusto, di elaborazione del concetto di bellezza. La funzione esaltatoria della comunicazione pubblicitaria viene così trasposta nella definizione di un racconto che si confonde nell'immagine stessa. La lattina della birra Budweiser o il pacchetto di sigarette Pall Mall rappresentano l'orizzonte di un paesaggio popolare, quotidiano, che nella sua familiarità riconosce una sincera idea di bello: sono i protagonisti di una realtà esterna che l'immagine artistica riconosce e protegge. I sistemi di manipolazione del gusto si mettono al servizio dell'arte, dettando ritmi e condizioni per un nuovo modello di rappresentazione. È ciò che si verifica soprattutto negli *Assemblages*, dove la realtà dell'immagine è supportata dall'oggetto fisico, come nella famosa opera *Bathtub Collage #1* del 1963, o in altre, sempre della serie *Still Life*, o ancora in *Interior #2* del 1964. Tutte opere che aggiungono uno spessore oggettuale a una ridefinizione del reale che vuole essere innan-

zitutto l'affermazione di un gusto, di uno stile di vita. Nessun mimetismo, ma nemmeno le suggestioni new dada di Rauschenberg: solo l'accento su una presenza di dettaglio che, come per il suggerimento di Magritte, sconcerta l'idea di verità.

È già nei piccoli collage della fine degli anni Cinquanta che Tom Wesselmann introduce il tema del nudo femminile come sorta di parametro interpretativo e come elemento volumetrico: figure semplici, poco più che sagome posizionate in grande evidenza sullo spazio scenico. Sono immagini che, almeno in questa prima fase, non assumono una particolare valenza erotica, giocando più sul piano compositivo e – raccogliendo l'insegnamento di Matisse – organizzando lo spazio per superfici sovrapposte. La pittura è piatta, poco attraente per uno sguardo che deve sfogliare i piani cromatici e i dettagli, la sommarietà della figura, come in *Judy Undressing* del 1960; tuttavia essa consente di catturare la sorprendente ricchezza del frammento e l'eleganza del collage. Ciò che queste opere introducono si svilupperà in pochissimo tempo, approdando già con *Great American Nude #1* del 1961 a un protagonismo della figura che caratterizzerà tutta l'arte di Wesselmann negli anni successivi. È l'immagine di una figura riflessa, già subdolamente deformata dai codici comunicativi, una figura attentamente costruita e ordinata anche nella sua apparente naturalezza. Non è tanto il nudo femminile che attrae Wesselmann, bensì la riproduzione pittorica o pubblicitaria di quel nudo. Non è quindi la modella come emblema della bellezza femminile il soggetto di queste opere, ma l'immagine astratta di quel soggetto. A volte una citazione colta sui grandi pittori del passato, altre volte un atteggiamento cleptomane dalle immagini stradali, il nudo di Wesselmann si dimostra impermeabile a uno sguardo morboso. Anche quando una sottile sensualità accarezza le forme femminili, giocando sulle linee e soffermandosi sulle forme,

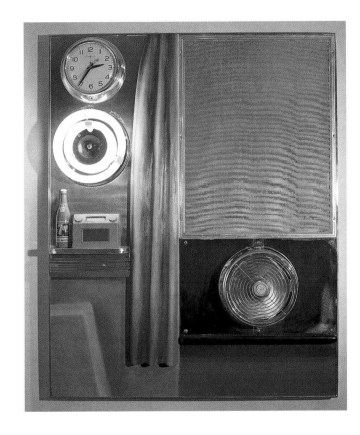

"rips," of which Mimmo Rotella was also a leader in the same years, one can recognize the rhapsodic visionary approach of Kurt Schwitters. Also in his smaller collages a few years later, the excited atmosphere of extreme and dissatisfied experimentation dissolves into the definition of decorative details, as can be seen in that intrusive and proliferating wallpaper which, as in Vuillard's paintings, envelops the image and suffocates it in chaotic and exciting narration. As in the warehouse of a junk dealer, the objects pile up together in a confused mass, and the images and shapes of these collages are the formal anticipation of that focus on detail and syncopated narrative that was to become the baseline of Wesselmann's art. An anticipation which is especially clear in the "Collage Paintings" of the early sixties, in which the intuitions of the previous years unfold in all their overpowering linguistic innovation. These are the works of the "Still Life" series in which the narrative structure definitively recognizes the role of popular imagery, not just in the process of communication but also in that of the establishment of taste, in the formulation of the concept of beauty. The eulogizing function of advertising communication is thus transposed into the definition of a narrative that merges into the image itself. The can of Budweiser beer or the packet of Pall Mall cigarettes are the horizon of a popular, everyday landscape that recognizes a sincere idea of beauty in their familiarity: they are the protagonists of an external reality that the artistic image recognizes and protects. The systems used to manipulate taste are put to the service of art, dictating rhythms and the conditions for a new model of representation. This is what happens especially in the "Assemblages," in which the reality of the picture is supported by the physical object, as in the famous work *Bathtub Collage #1* of 1963, or in others, again in the "Still Life" series, or in *Interior #2* of 1964.

These are all works that add a physical dimension to a redefinition of reality in what is primarily intended as the statement of a taste, and of a lifestyle. There is no mimicry, but nor are there the New Dada influences of Rauschenberg: there is just a stress on the presence of details that, as in Magritte's suggestion, disconcert the idea of truth.

Already in the small collages of the late fifties, Tom Wesselmann was introducing the theme of the female nude as a sort of interpretational parameter and as a single volumetric element: simple figures, little more than outlines placed most conspicuously in the area of the scene. These are images that, at least in this initial phase, have no great erotic impact, for they act more on the compositional level and, learning from the teachings of Magritte, organize the space in overlapping surfaces. The painting is flat, not particularly appealing to an eye that is obliged to leaf through the layers of color and details, while the schematic aspect of the figure, as in *Judy Undressing* of 1960, does however make it possible to capture all the extraordinary richness of the fragment and the elegance of the collage. What these works introduced was rapidly developed and a led to the *Great American Nude #1* of 1961, in which the domination of the figure, which was to be the hallmark of Wesselmann's art in the following years, is already apparent. It is the image of a reflected figure, already insidiously deformed by codes of communication, a carefully constructed figure, well-ordered even its apparent naturalness. Wesselmann is attracted not so much by the female nude as by the pictorial or advertising reproduction of that nude. So the subject of these works is not the model as an emblem of female beauty, but the abstract image of that subject. At times a learned quotation from the great painters of the past, at other times a kleptomaniacal attitude to images from the streets, Wesselmann's nudes prove to be imperme-

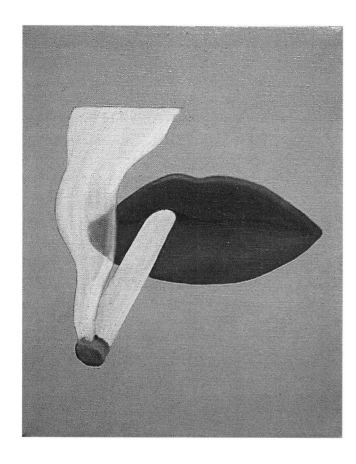

Smoker Study #41, *1967*

anche quando traspare un velato erotismo che ricorda l'eleganza di Modigliani, Wesselmann stempera la tensione accentuando la sagoma femminile e prosciugando la vibrazione coloristica. Anzi, il colore appare plastico, irreale, lucido e piatto come le immagini industriali: da un lato acceca di lucentezza immaginifica, dall'altro si stende opaco e uniforme in una scena familiare. Allo stesso tempo il dato cromatico contribuisce ad accentuare quella struttura narrativa che consente alla figura di disporsi in un fitto intreccio di forme e di linee; proprio la squillante plasticità coloristica conferisce al racconto un nuovo paesaggio formale e un nuovo orizzonte interpretativo. Si comprende così bene il ricorso ai metalli laccati, alle plastiche, al plexiglas, cioè a tutti quei materiali che esaltano l'inconsistenza del colore e la pura semplicità delle forme.

La composizione elementare di linee descrittive e una gioiosa epifania cromatica consentono a Tom Wesselmann di allargare o stringere l'ottica visuale, offrendo allo sguardo ora immagini nitide e ben impaginate, ora dettagli più sfumati e contorti. Si scopre allora una sorprendente venatura astratta che ci riporta alla mente i primi collage, quegli strappi e quelle sovrapposizioni attraverso i quali l'immagine si svelava. Non si tratta tanto di un processo formale di sintesi astratta, quanto piuttosto della radicalizzazione di una costante di tutta la poetica dell'artista: si tratta di concentrare l'attenzione sul linguaggio e sulle sue componenti letterali. L'ingigantimento dei segni primari e il loro confondersi nel gioco delle sovrapposizioni alimentano un equivoco astratto che in realtà nasconde un rigoroso approfondimento sul ruolo e sulla funzione del frammento grammaticale.

Tutto ciò si evidenzia con stupefacente chiarezza attraverso l'analisi dei disegni e degli studi preparatori, lungo i quali scorre un flusso creativo che si presenta in tutta la sua schiettezza e propone, senza remore o indecisioni, i temi della narrazione e i suoi protagonisti. Pastelli, grafite, inchiostri spalancano un mondo di straordinaria fantasia e infantile voracità d'immagini che brilla nell'immediatezza di un tratto sicuro e capace. Sia che la matita viva nel ruvido contrasto del bianco e nero, sia che le cere accostino colori vivaci, la figura recita la propria parte con grande leggerezza e divertita ironia.

L'arte di Tom Wesselmann rappresenta certamente un'importante pagina della storia dell'arte e un intelligente stimolo per l'attualità, ma anche un nuovo approccio all'interpretazione artistica del mondo, una nuova volontà rappresentativa, una fiducia nel linguaggio e nelle sue capacità di raccontare la realtà. È un'arte immediatamente amica, a tratti complice, elegantemente sospesa fra un'immagine patinata e sorridente e una narrazione inaspettatamente complessa, ricca di citazioni sociologiche o letterarie, sottilmente concettuale, quasi metafisica.

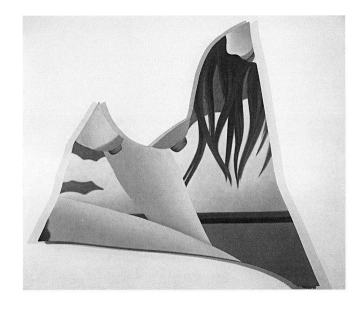

Seascape #31, *1967-1980*

able to morbid eyes. Even when a subtle sensuality caresses the female forms, playing on the lines and lingering on the shapes, even when a veiled eroticism shows through, recalling the elegance of Modigliani, Wesselmann softens the tension by accentuating the female outline and draining away the vibrancy of color. Indeed, the color appears plastic, unreal, glossy and flat, like industrial pictures. On the one hand, the highly imaginative brilliance is blinding, while on the other it is spread opaquely and uniformly in a familiar scene. And yet, at the same time, the color helps accentuate the narrative structure that enables the figure to be arranged in a serried interweaving of shapes and lines. It is precisely the shrill coloristic plasticity that gives the tale a new formal landscape and a new horizon of interpretation. What is instantly clear is the resort to lacquered metals, to plastics and Plexiglas, and to all those materials that emphasize and exalt the inconsistency of color and the pure simplicity of form.

The elementary composition of descriptive lines and a festive epiphany of color enable Tom Wesselmann to broaden or restrict his focus, offering us clear, carefully structured images at times, or more indistinct and contorted details at others. So we discover a surprising abstract vein that brings to mind the first collages, those rents and superimpositions through which the image was revealed. It is not so much a formal process of abstract synthesis as the radicalization of a constant that runs throughout his creativity: in other words, the way he concentrates on language and on its literal components. The extreme magnification of the primary signs and their blending into the play of superimpositions leads to an abstract misapprehension that actually conceals a scrupulous examination of the role and function of the fragment of grammar.

All this can be observed with astonishing clarity by ana-

lyzing the drawings and preparatory sketches: they reveal a stream of creativity that appears in all its candor, unhesitatingly offering us the protagonists and the themes of its narrative. Pastels, pencil and inks open wide a world of extraordinary imagination and a childlike desire to devour images whose splendor can be seen in the immediacy of a sure and highly skilled hand. Just as the pencil indulges in the rough contrast between black and white, and the pastels bring together lively colors, so does the figure play its own role with lightheartedness and wry irony.

Tom Wesselmann's art is certainly an important page in the history of art and an intelligent stimulus for its topicality, but it also provides us with a new approach to an artistic interpretation of the world, a new desire to represent, a new trust in language and in its ability to narrate reality. This art becomes an instant friend, sometimes it is complicit, elegantly suspended between a smiling, glossy image and an unexpectedly complex tale, replete with sociological or literary quotations. Subtly conceptual. Almost metaphysical.

Note su Tom Wesselmann

Slim Stealingworth

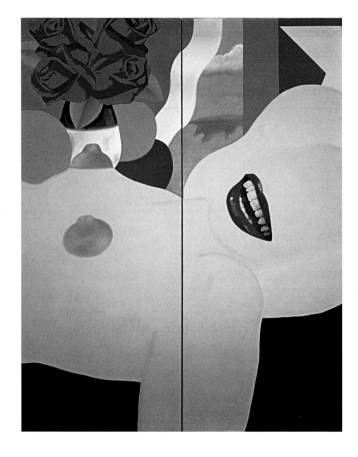

Great American Nude #53, *1968*

Nel 1959 Tom Wesselmann fu improvvisamente strappato alle amorevoli braccia della Cooper Union (la scuola d'arte che frequentava a New York City) e catapultato nel bel mezzo del mondo artistico newyorkese, denso, ribollente e fremente di attività come un vulcano prima di un'eruzione. Sullo sfondo la scuola dei pittori di New York, artisti coinvolti a tal punto nella rivoluzione astrattista da riuscire a conquistarle tutta una serie di settori artistici diversi e a iniettare dosi massicce di creatività in pittura, scultura, danza, cinema e poesia, tanto per citare solo alcuni ambiti. Dalla New York degli anni Sessanta promanava un'atmosfera quanto mai elettrica.

E fu in questo *mare magnum* di febbrile attività che Tom Wesselmann cominciò timidamente ad avventurarsi. Ma con le idee chiare: il giovane artista infatti desiderava entrare a far parte di quel mondo, ma non identificarvisi: fornire il suo apporto a quel clima di eccitazione generale, pur mantenendo una propria, indiscutibile unicità. Negli anni della formazione DeKooning era stato per lui un idolo, ma in quel momento Wesselmann capì chiaramente che la sua vocazione consisteva nell'innamorarsi, non più dell'opera altrui, ma della propria. E come riuscirci? Per prima cosa Wesselmann decise di privarsi di tutto ciò che più amava in DeKooning e di imboccare la strada esattamente opposta a quella del maestro, dedicandosi allo stile figurativo tradizionale. Una decisione astratta, di per sé, dato che all'epoca l'artista non era attratto da possibili contenuti da rappresentare: il nudo, infatti, costituiva per lui oggetto di interesse in sé, ma non per questo egli si appassionava a "rappresentarlo": tale atteggiamento era destinato a mutare negli anni a venire.

Anche l'opera di Matisse esercitava un fascino particolare su Wesselmann in quel periodo, ed egli ancora una volta, mentre sviluppava il proprio approccio all'arte soprattutto tastando il terreno della rappresentazione figurativa, decise di rinunciare a tutto ciò che di Matisse maggiormente lo colpiva; egli decise,

per esempio, che là dove Matisse esasperava un particolare del corpo, lui lo avrebbe raffigurato senza la minima esagerazione. Rendere la propria opera assolutamente neutra, e quindi cominciare a sovraccaricarla partendo, per così dire, dal livello zero: ecco l'intenzione di Wesselmann, determinato a fare della pittura figurativa una forma d'arte che entusiasmasse il pubblico tanto quanto DeKooning entusiasmava lui.

Già negli anni Sessanta, così come nei decenni seguenti e fino a oggi, l'attenzione di Wesselmann si concentrò sempre più sulla forma che le immagini andavano via via assumendo piuttosto che sulla loro rappresentazione sulla tela. Le opere dipinte dall'autore durante il decennio Sessanta-Settanta sono così meravigliosamente eterogenee da rendere impossibile una descrizione sintetica: sia i contenuti, sia la forma di tali opere, infatti, evidenziano una grande varietà immaginativa, e contengono il leitmotiv di tutta l'opera dell'artista, così come si è sviluppata negli anni e così come si configura allo stato attuale. L'irrequieto Wesselmann continuò a spaziare con la velocità del fulmine fra le innumerevoli possibilità artistiche che via via si rivelavano alla sua attenzione sempre viva; nei paragrafi che seguono noi ci limiteremo a delineare, semplificandole e sistematizzandole per quanto è possibile, le principali direttrici di tali scelte.

Segnarono l'inizio degli anni Sessanta alcuni collage di piccole dimensioni, raffiguranti nudi e teste femminili e calibrati sulle misure ridotte del materiale più agevolmente reperibile. Ma Wesselmann aveva in mente di espandere la scala delle sue opere, e a tal fine cominciò a collezionare tessere di volume più consistente: a volte l'artista si adattava a raccogliere dai cestini delle immondizie di qualche stazione del metro i poster sporchi e bagnati appena staccati, o perfino a rubare qualche cartellone dagli interni dei treni. Insieme ai nudi frutto del suo pennello, queste tessere da collage così particolari furono la carta vincente delle nature morte più riuscite di Wesselmann.

Notes on Tom Wesselmann

Slim Stealingworth

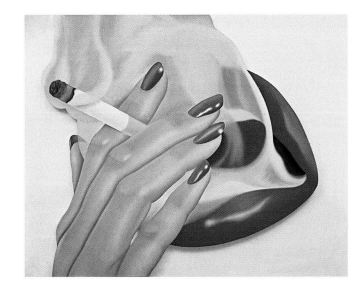

Smoker #9, *1973*

In 1959 Tom Wesselmann was abruptly thrust from the protective arms of The Cooper Union (his art school in New York City) into the intense and heady excitement of the erupting New York art world. The stage was set by the New York School of painters, and the abstract revolution they had been fomenting seemed to spread suddenly to numerous areas of artistic activity, spurring renewed creativity in painting, sculpture, dance, films, poetry and more. New York was electric in the sixties.

Into this exciting maelstrom, Tom Wesselmann ventured, with trepidation. He wanted to be a part of it but not like it. He wanted to be unique, while still contributing to the excitement. In art school, DeKooning had been his idol, but now Wesselmann realized he had to find his own passion. In order to do this, he felt he had to deny to himself all that he loved in DeKooning, and go in as opposite a direction as possible. He turned to conventional, representational imagery. This decision was an abstraction in itself because at the time he had no interest in painting representational subject matter. It's not that he wasn't interested in nudes—he wasn't interested in their *depiction*. That attitude would change with time.

At the same time, Wesselmann was also drawn to the work of Matisse and as his own art began to evolve and explore figuration he was also determined to deny to himself much of what he admired in Matisse. For example, where Matisse might exaggerate a body part, Wesselmann decided to have no exaggerations. He wanted to make his work as neutral as possible, and then to find ways to supercharge it, starting, in effect, from zero. His goal became to make representational paintings as exciting as the DeKoonings were to him.

Wesselmann's main interest in the sixties, and up to the present time, was focused more on the form his images took, and less on the images depicted. His work through the sixties is so extraordinarily diverse that it can't be described in a few brief statements. He produced a great diversity of subject matter and form and set the pattern that has underlain all of his work up to and including the present. He moved with restless speed through the seemingly endless number of possibilities he unearthed. The paragraphs below will attempt to categorize and simplify many of these directions.

His earliest sixties works were quite small collages of nudes and women's heads. Readily available collage materials tend to be small, and that set the scale of those works. Yearning for a larger scale, Wesselmann began accumulating larger collage elements. Sometimes, to do this, he had to salvage just-removed wet and dirty subway station posters from the trash, and even at times had to steal a poster from a train. These collage materials reinforced painted nudes and also became major still life elements.

The first works that brought Wesselmann to the attention of the art world were the "Great American Nudes". They began in 1961 when he was having difficulty establishing a personal color vocabulary—there were simply too many colors to choose from, and his choices often felt arbitrary to him. At that juncture he needed a way to limit his palette, and at the moment of greatest concern, he had a dream about the colors red, white and blue. When he awoke, he decided to do the "Great American Nude", limiting his palette to those colors and any related patriotic colors, such as gold fringe on a flag, khaki—the color of his old army uniform, etc. Of course, he used true colors of real elements such as roses or oranges, etc. Gradually, this limited palette dropped away, having served its purpose, although the "Great American Nudes" continued into the early seventies. *Great American Nude #1*, 1961 began the series, and when the total became 100, Wesselmann did a small number of other nudes without that title, where he explored several more eccentric shapes.

Fu solo con i *Great American Nudes*, cui l'artista pose mano nel 1961, che il mondo dell'arte si accorse finalmente di Wesselmann. E questo mentre egli si misurava, non senza difficoltà, con la necessità di elaborare un proprio, originale linguaggio cromatico: egli avvertiva infati l'esigenza di individuare un criterio dirimente che ponesse un argine alla sterminata varietà delle possibili gamme cromatiche e che scalzasse l'arbitrarietà della scelta di questo o quel colore. E in quel momento di incertezza fu un sogno a venirgli in aiuto, nel quale campeggiavano i tre colori patriottici per eccellenza: il rosso, il bianco e il blu. La scelta era fatta, il criterio infine trovato: e Wesselmann decise di produrre i *Great American Nudes* giocando esclusivamente su questi e altri colori connessi all'idea della patria (l'oro delle frange di una bandiera, il kaki della sua vecchia uniforme di fanteria, ecc.), in forma di estratti ricavati da oggetti della realtà quali, per esempio, rose o arance. Si trattò, è vero, di una fase transitoria; pure, anche se gli ultimi *Great Nudes* risalgono all'inizio degli anni Settanta, l'uso di quella tavolozza scarna, poi abbandonata, svolse anch'essa una funzione nell'evoluzione dell'artista. Il *Great American Nude #1*, 1961, inaugurò una serie di cento opere, cui seguirono altre contenenti variazioni sul tema delle forme impiegate, decisamente eccentriche.

Wesselmann cominciò a cimentarsi con le nature morte nel 1962, strutturandole per lo più intorno a tessere di collage che rappresentavano i marchi di prodotti famosi. A tale scelta già di per sé originale andò ad aggiungersi l'idea di integrare l'effetto visivo con quello sonoro, nata del tutto occasionalmente: l'artista si trovava infatti una volta alla National Gallery of Art, immerso nella contemplazione di un paesaggio, che si arricchì improvvisamente di nuovi echi e di una qualità misteriosamente intensa grazie allo scricchiolio delle scarpe di uno dei custodi, che all'artista evocava il frinire dei grilli. Se per un verso Wesselmann intendeva mantenere la caratteristica bidimensionalità dei suoi dipinti, dall'altro si imbatteva in interessanti materiali di ogni genere, come per esempio una serie di finestre che per prime vennero inserite in un nudo; finché, a un dato momento, l'artista intraprese decisamente la ricerca di materiali pittorici quanto mai disparati, a due e tre dimensioni, da impiegare nelle sue opere, a condizione che fossero grandi, o addirittura enormi, nell'intento di conferire alle nature morte un carattere non più intimista, ma monumentale. Lo attiravano in modo irresistibile, infatti, i cartelloni pubblicitari – simili a ciclopiche tessere da collage situate ai bordi delle autostrade – che collezionava, facendoseli inviare dalle ditte specializzate e dispiegandoli, pieno di entusiasmo, sul pavimento di casa ogni volta che uno nuovo emergeva dalla posta, affascinato dal reticolo dei puntini litografici tipici del primissimo piano, che conferivano a quelle immagini un indiscutibile "non so che" che le rendeva affascinanti ai suoi occhi di artista. Proprio questi materiali costituirono l'humus su cui crebbero poi le nature morte giganti; infatti, mentre la disponibilità di materiale per i collage più piccoli non richiedeva l'integrazione delle immagini da parte del pittore, la scarsità e la poca versatilità di questi enormi cartelloni-tessera richiese un intervento pittorico via via più consistente, che portò gradualmente all'abbandono totale del collage, sostituito una volta per tutte da pennello e colori.

Le linee di sviluppo dell'opera di Wesselmann si intrecciano e si sovrappongono senza posa, tanto che tracciarne una presentazione rigidamente cronologica risulta, se non proprio impossibile, senz'altro poco fruttuoso. L'artista rivoluzionò le dimensioni del collage tradizionale, espandendone senza misura i limiti e servendosi di oggetti a 3D di ogni genere. Un esempio dalla serie dei *Bathtub Collage*: il soggetto è un nudo, ambientato in una stanza da bagno e circondato da oggetti inequivocabilmente reali, quali un sedile per WC, un rotolo di carta igienica, un portasapone, una tenda per la doccia ecc., capaci di impregnare l'immagine di una corporeità vivida e scioccante. Wesselmann fu costretto a interrompere questo ciclo, che pure lo assorbiva interamente, dopo aver realizzato solo sei opere, perché spinto dall'ansia di gettarsi in tutta una serie di altri lavori, altrettanto coinvolgenti e altrettanto urgenti.

Wesselmann aveva fatto propria la lezione del collage e aveva appreso che la giustapposizione di vari tipi di raffigurazione fondati su oggetti reali può evocare tra questi ultimi un'intera gamma di rimandi incrociati, analoghi a quelli che riecheggiano e rimbalzano, a livello visivo, fra gli oggetti reali stessi e fra questi e le zone dipinte nel contesto della vita reale. L'artista, quindi, si pose l'obiettivo di inoculare questi sottili riverberi nei suoi lavori introducendovi un numero sempre crescente di elementi tridimensionali. Ed ecco perché Wesselmann inserì in alcune opere addirittura dei televisori accesi, affascinato com'era dalla spietata concorrenza che alla parte pittorica facevano le immagini in movimento e le luci e i suoni del piccolo schermo; ed ecco perché i nudi vennero contornati da connotazioni di ambiente quali tappeti, tavoli, sedie, finestre assolutamente reali. Sebbene queste opere si configurassero come ovviamente e completamente tridimensionali, Wesselmann dichiarò nel 1963: "Il concetto di pittura alla radice della mia opera è quello di immagine bidimensionale. La terza dimensione esiste solo per intensificare l'immagine bidimensionale". Contemplando tali opere, che in qualche misura ponevano l'accento sull'ambiente, il pubblico poteva ricavare l'impressione di un invito a camminare sul tappeto o a sedersi sulla sedia contenuti nel quadro, quasi che il pittore invocasse un'interazione tra quest'ultimo e il pubblico. Ma Wesselmann rifiutava tutto ciò, senza mezzi termini.

Wesselmann, proseguendo con le sue sperimentazioni, a un certo punto si pose una sfida ben precisa: quanti oggetti reali è possibile inserire nello spazio limitato di un'opera, senza pri-

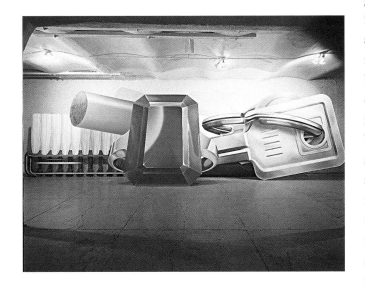

The still lifes began in 1962 and were most often built around collaged elements depicting brand name products The addition of sound was provoked by the squeaky shoes of a guard at The National Gallery of Art—Wesselmann was looking at a landscape, and the shoes sounded like crickets, and added a moment of additional interest to the image. Wesselmann was determined to keep his paintings flat, but he had been accumulating objects found in the street; his first found object was a set of windows, which he put into a nude painting. Soon he intently pursued any and all pictorial elements, both 2-D and 3-D, and the bigger the better. The "bigger" soon took the form of the "biggest". He wanted to change the scale of traditional still life from intimate to monumental. He noted billboards along the highways, and wrote many letters to the appropriate companies, and accumulated a significant inventory of actual billboard sheets. They were irresistible, super-sized collage pieces. When a new billboard arrived in the mail, opening it and spreading it out on the floor was an exciting event. Up close, the lithographic dot patterns alone gave the images a special kick. The giant still lifes came out of these materials. In his smaller collage-based works he didn't have to paint quite as much, because of the large quantity of available parts, but with the relative scarcity of billboard parts that could be utilized throughout an image, Wesselmann had to paint more and more. This began a direction of less collage and more painting, until rather soon he dropped collage.

So many of Wesselmann's directions overlap that it is cumbersome to try to present them in a strict chronological order. At the same time he was liberating his collage scale, he was accumulating and using 3-D objects of all kinds. In the "Bathtub Collage" series, he presented a nude in a bathroom situation, surrounded by, for example, a real toilet seat, toilet paper roll, soap dish, shower curtain, etc. These objects gave the image an explosively vivid presence. While he was still deeply involved with these, he was forced to stop after doing only six, because there were so many other equally pressing works to begin.

Wesselmann wanted to incorporate more 3-D elements into his nudes and still lifes. He had learned in his usage of collage that a mix of various kinds of reality-based imagery can produce many reverberations between these images. Similarly, he realized that real objects reverberate interestingly with each other and with painted areas in a real-life context. He inserted working TV sets into some paintings, interested in the competitive demands a TV, with moving images and giving off light and sound, can make on painted portions. He began doing nudes with more environmental implications, using a real rug on the floor, for example, and real tables and chairs, windows, etc. Although these works were fully and obviously 3-D, Wesselmann said, in 1963, "I work in a painting concept—a two dimensional image. The third dimension exists only to intensify the two dimensional image." In these somewhat environmental works, people sometimes felt they were being invited to walk on the rug, or sit on the chair, to interact with the painting. This was totally unacceptable to the artist.

In a similar vein, Wesselmann wanted to see how many real objects he could put into a confined space and have a result that would be both intense and logical. (He was *not*, as many would say, trying to describe a typical American home.) He did not want these images to be too cloyingly real, too explicitly literal, as though he were trying to recreate a household setting, so he made them all gray, to keep them in an art context.

Interior #2, 1964 is a perfect example of this series. It has a working fan, which Wesselmann had chrome plated, a working light and clock, several 3-D assemblage elements, some custom made, some found, and a real window screen

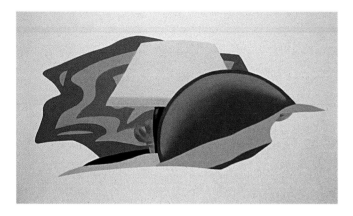

vare quest'ultima, nel contempo, di capacità suggestiva e logica razionale? Qui c'è chi ha banalizzato l'intento dell'artista riducendolo alla raffigurazione di una tipica casa americana, cosa decisamente estranea all'obiettivo; e per non dare l'impressione di voler copiare l'ambientazione di una casa, per non annoiare l'osservatore con immagini troppo prosaicamente reali, troppo scontatamente letterali, egli presentò al pubblico immagini completamente grigie, inseribili quindi solo in un contesto artistico.

Interior #2, 1964: ecco un esempio caratteristico della serie, che contiene un ventilatore funzionante, cromato dallo stesso Wesselmann, una lampada accesa e un orologio anch'esso in funzione, oltre a numerosi assemblaggi a 3D, alcuni creati su misura dall'artista, altri rinvenuti casualmente, e un vero telaio di finestra che funge da cornice a un poster in bianco e nero di Chicago.

L'artista era in procinto di mettere mano a un interno completamente in rame, ma dopo la quarta opera della serie degli *Interiors*, ancora una volta l'urgenza di altri progetti incombenti ebbe il meglio su quello già in corso.

Nel 1964 Wesselmann operò un'innovazione radicale nelle sue nature morte: a livello di realizzazione, infatti, isolò alcuni ritagli su uno scaffale in formica tridimensionale, e sul piano teoretico sostituì a una concezione tradizionale una *ratio* imperniata sulla pura immagine. Il tenace interesse per la composizione che innerva tutta l'opera di Wesselmann venne soppiantato, per gran parte del 1964, dallo studio dell'immagine "per sé", che sarebbe sfociato nella creazione dei quadri plastici. Sull'onda del desiderio di produrre più copie di un quadro particolarmente ben riuscito (tipico degli scultori), Wesselmann fece una breve incursione nel mondo delle opere plastiche, che peraltro prediligeva, producendo inizialmente due tipi di forme, di cui una illuminata (più efficacemente suggestiva) e l'altra no. L'autore scelse come fonte di ispirazione di questi lavori i

segnali dei distributori di benzina, ma più per la forza che questi irradiavano che per ragioni sociologiche o consumistiche.

Negli anni Sessanta vediamo Wesselmann impegnato anche sul fronte delle tele sagomate, che con la loro forma esterna quanto mai irregolare, costrinsero l'artista a operare la scelta di circoscrivere parti dell'immagine, escludendone giocoforza altre. Wesselmann applicò queste suggestioni all'iconografia del nudo, racchiudendo nel disuguale perimetro della tela il nudo stesso insieme a elementi della sua ambientazione.

L'influsso delle tele sagomate si dispiegò appieno nella serie *Drop-Out*, inaugurata nel 1967, ove esse delineavano, per esempio, la forma interna in negativo descritta dalla triangolazione del busto (compreso il seno) con un braccio e una gamba. È praticamente impossibile spiegare questo concetto a un lettore: l'idea sottostante è che la forma in negativo racchiuda ciò che al suo interno è visibile sullo sfondo, e si trasformi quindi, al contempo, in forma in positivo. Per esempio:

Verso la metà degli anni Sessanta Wesselmann decise di modificare le proporzioni interne dei propri nudi, con l'obiettivo di incrementare la forza e l'efficacia grafica degli oggetti di piccole dimensioni che accompagnavano i nudi, come frutta e fiori; per tale ragione l'artista "zoomò" su una parte del corpo, per esempio un seno o un piede, che divenne a pieno titolo il fulcro del quadro. Così esordì la rimarchevole serie dei *Bedroom Painting*.

Il risultato dell'imporsi graduale di questo nuovo punto di vista condusse Wesselmann alla rappresentazione della bocca, esito di una modalità innovativa di affronto della figura umana. Nel 1967 Wesselmann stava dipingendo la bocca di un'amica che posava per lui, e quando questa si accese una sigaretta l'ar-

Bedroom Face with Lichtenstein (3-D), *1988-1992*

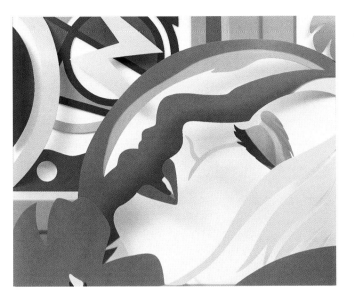

framing a black and white poster of Chicago. He was about to start an all copper interior, but after doing only four in the "Interior" series, he was again pulled away by the pressure of other projects.

In 1964, Wesselmann made a major change in his still lifes from a more traditional compositional concept to a more purely image concept. To do this, he isolated two or three elements in cut-out form, on a three dimensional Formica covered shelf. Wesselmann's work has always been marked by a concern for composition, and still is, but throughout much of 1964, compositional power was replaced by a simple image power. This focus led to the plastic paintings. A desire to make a major painting in a multiple number, as sculptors often do, was the initial impetus for Wesselmann's foray into plastic paintings. His early plastic 3-D forms, on which he painted, took two basic directions, one illuminated, one not. He very much liked the plastic surface, painted on the back, but the illuminated ones were the most intense, for obvious reasons. They were inspired by gas station signs, but he used the medium because of its exciting presence, and not for sociological or consumerism commentary.

The sixties also saw Wesselmann drawn deeply into shaped canvas, especially into situations where the outer shape of the canvas traces an irregular inclusion of certain parts of the image and excludes other parts. This involvement primarily focused on the nude imagery, where the nude and selected parts of her environment are included in the irregular shape.

One area in which his shaped canvasses were paramount was in the "Drop-Out" series, begun in 1967. In these, the shaped canvas, for example, outlined the interior negative shape formed by the triangulation of the torso (including the breast), with an arm and a leg. While this is quite impossible to make clear to a reader, that negative shape depicts what one might see in the background, inside that shape, and becomes the positive shape. For example:

In the middle sixties, Wesselmann wanted to change the internal scale of his nudes, so that the small objects, such as fruit or flowers, that accompanied the nudes, could take on far more graphic power. He therefore moved in for a close-up, making a part of the body, such as a breast or foot., the central focus of the painting. This began the very important "Bedroom Painting" series.

As this changed viewpoint was taking shape, Wesselmann began drawing mouths, as a separate approach to another way of dealing with the figure. In 1967, he was drawing a friend's mouth, when she took a cigarette break. Intrigued, Wesselmann kept drawing. There is a kind of internal evolutionary innocence in Wesselmann's work process. One thing leads to another and another and so on, and never ends. The first "Mouth" paintings depicted a mouth alone or with a cigarette. Wesselmann kept these simple and unglamorous, so as to avoid the look of lipstick advertisements. Rather soon, he added smoke to the cigarettes and thereby began the "Smoker" series, *Smoker Study # 41*, 1967 is a good example of this series. (In the seventies he added a hand to the image, which made the paintings more complex). Again, the shaped canvas was dominant in that its outlines followed the mouth and bursts of smoke. While many have commented on the sexual innuendo implied in the "Smokers", that is purely in the minds of those beholders, and not in Wesselmann's. This situation, as always, is for Wesselmann, a means to make an exciting painting, nothing more. As to smoking itself, he

tista continuò la sua opera, inserendo anche l'oggetto nella raffigurazione, che acquistò una qualità di evoluzione interna e pura in cui ogni passo conduceva al successivo, in una sequenza senza fine. I primi quadri, che riproducono la sola bocca, oppure questa che regge la sigaretta, sono rimasti volutamente lineari e privi di glamour; anzi, Wesselmann evitò di proposito di rifarsi alle pubblicità dei rossetti. Le sigarette vennero poi arricchite da nuvole di fumo: così nacque anche la serie *Smoker*, di cui è un esempio caratteristico lo *Smoker Study # 41*, 1967 (negli anni Settanta l'immagine verrà arricchita dalla presenza di una mano); e ancora una volta è tangibile l'influsso della tela sagomata, i cui margini seguono il profilo della bocca e l'andamento delle nuvole di fumo. Parecchi osservatori hanno voluto notare nella serie degli *Smokers* un esplicito riferimento sessuale, ma si tratta di un'intenzione estranea all'autore che, come gli è tipico, sfruttò la situazione in oggetto per rendere il quadro interessante, ma senza secondi fini; quanto al fumo in sé, poi, egli addirittura lo detestava (Wesselmann era stato fumatore, non dei più convinti, fino alla mattina in cui il "New York Times" pubblicò per la prima volta un titolo che accennava al rapporto tra fumo e tumore del polmone: in men che non si dica l'artista gettò via tutte le sigarette e non si azzardò mai più a fumarne una).

Un ultimo e fondamentale capitolo dell'opera di Wesselmann si aprì verso la fine degli anni Sessanta; egli si adoperò, infatti, per esasperare ulteriormente le dimensioni già sproporzionate delle sue nature morte, accentuando nel contempo l'aspetto paesaggistico della propria opera: un duplice intento che condusse alla creazione di nature morte gigantesche dove, per esempio, un paio di occhiali da sole largo quasi dieci metri stava appoggiato su una tela sagomata *ad hoc*. Spesso Wesselmann combinava una quantità di questi oggetti smisurati, tutti poggiati sul pavimento o talvolta su una specie di grande tappeto dipinto

come fosse una tovaglia. Il risultato è un contrasto decisamente insolito fra l'osservatore e l'iconografia della natura morta.

Negli anni Settanta l'artista portò avanti i suoi studi lungo i filoni di attività apertisi già del decennio precedente; nacquero quindi, principalmente, enormi nature morte appoggiate su varie superfici, in cui ogni componente era come un quadro con una sua forma particolarissima. La natura morta oggetto di questo assemblaggio di elementi era collocata su un pavimento, talvolta su un rivestimento che fungeva da tovaglia. In questo decennio Wesselmann si accostò anche alla scultura 3D per esterni.

Nel 1983 una nuova idea affascinò Wesselmann: realizzare un disegno in acciaio come se questo fosse stato disegnato originalmente nel metallo, comprese tutte le righe "sbagliate"; e l'aspetto più intrigante era per l'artista proprio immaginare di riuscire a sollevare un disegno tenendolo per le linee che lo formano e a trasportarlo come se fosse un oggetto. L'impressione che questi "disegni di acciaio" producevano sull'osservatore una volta appesi a una parete era che vi fossero stati dipinti direttamente: una suggestione che l'artista creava con la sua lungimiranza, precedente alla nascita della tecnologia capace di farne una realtà grazie alla precisione della meccanica. Lo studio di un sistema in grado di realizzare questa idea richiese buona parte di un anno, e nell'attesa l'inquieto Wesselmann si dedicò a un ennesimo progetto, ovvero rielaborare due delle situazioni dei primi anni Sessanta.

Wesselmann scelse una sua opera dell'epoca, il *Great American Nude #8*, e si pose a ricomporla e a ridipingerla in una nuova versione, a ventitré anni di distanza, ricavando dalla realtà più pose principali, modificando alcune componenti forti e mantenendo invariata l'idea guida; il tutto, ovviamente, condito dalle inevitabili modifiche stilistiche apportate dai due decenni intercorsi. Il risultato fu un'opera del tutto nuova, il *Great American Nude #8+23*, 1984-1994, permeata di un fasci-

no tutto particolare, dovuta al fatto di essere, per così dire, sospesa tra passato e presente.

Degli anni Ottanta si può tracciare il bilancio di una notevole creatività imperniata sul concetto dei ritagli di metallo: inizialmente si trattava di ritagli a 2D di varie forme, disegnati dal vero in inchiostro nero e poi ritagliati da una lamina di acciaio o di alluminio, cui fecero seguito, dopo qualche tempo, lavori a 3D in alluminio.

Wesselmann si occupò della pittura astratta tridimensionale a partire dagli anni Novanta e fino al 2001, anno in cui l'artista si dedicò a rivisitare alcuni aspetti, fino ad allora inesplorati, dei nudi degli anni Sessanta secondo una modalità squisitamente espressionistica (si tratta di opere non ancora esposte al pubblico); da questi scaturirono più tardi i *Sunset Nudes* che, insieme ai quadri astratti, costituiscono attualmente il doppio fulcro dell'attività dell'autore.

Wesselmann non ama il termine "pop art" che molti storici dell'arte, curatori di mostre e critici usano come pretesto per concentrarsi eccessivamente sul soggetto e sul contenuto sociologico che pare esservi implicito, con la conseguenza che tali opere sembrano avere un contenuto letterario, invece che letterale. La motivazione profonda che informa l'arte di Wesselmann non è diversa da quella di un qualunque altro grande artista della storia, e consiste propriamente nell'intento di dare forma a ciò che egli stesso ogni giorno scopre come bello ed esaltante. Ai suoi occhi, quindi, l'arte è un esperimento sempre in svolgimento e mai definitivamente concluso, il cui obiettivo è una crescita: ma poiché questa non è mai acquisita in modo assoluto e definitivo, allora l'arte non può che essere costante divenire. L'opera attuale dell'artista, sia nei quadri astratti a 3D, sia nei nudi delle nuove tele, continua a testimoniare la forte impronta di questo impulso originale verso un inesausto miglioramento.

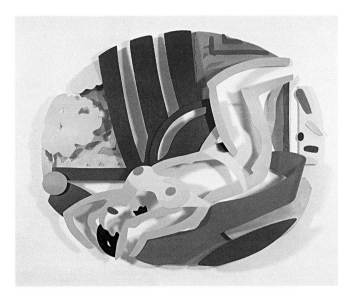

Nude Lying Back, *1993*

detests it. (He had been a light smoker until the morning the first *New York Times* headline of a link between smoking and lung cancer. He immediately threw away his cigarettes and never again smoked one.)

A final, important area in Wesselmann's work of the sixties unfolded near the end of the decade. He wanted to push the huge scale of the still lifes even more, and also to push further into the more environmental part of his work. This led to the giant still lifes, where a pair of sunglasses, for example, is almost thirty feet wide, and is its own separate canvas shape. He assembled a number of these huge elements, all standing on the floor, sometimes on a large section of indoor-outdoor carpeting, painted as a tablecloth. They form a most unusual confrontation between the viewer and still life imagery.

The seventies were largely occupied with furthering areas opened up in the sixties and were largely involved with the huge standing still lifes. In these works each element is a shaped painting. The assembled still life stands on the floor, sometimes on a floor covering serving as a table cloth. This decade was also a focus for his first fully 3-D outdoor sculptures.

In 1983, Wesselmann was seized by the idea of doing a drawing in steel as though it had somehow miraculously just been spontaneously drawn in steel, including all the "wrong" lines. He savored the prospect of being able to pick up a drawing by its lines and carry it. When hung on the wall, the resulting "steel drawings" looked as though they were drawn on the wall. This idea preceded the available technology to accomplish it with mechanical accuracy. In order to carry out his idea, he had to invest in the development of a system that could accomplish this. It took the better part of a year to do so, and while he was waiting, he turned his attention to another idea, of going back to two early sixties situations and dealing with them again.

He chose *Great American Nude #8*, and decided to compose and paint it as he would twenty three years later. He drew the basic pose many times, from life, and changed some of the basic elements, keeping the basic image relatively the same, except for the obvious stylistic difference caused by the passage of two decades. The new work is *Great American Nude #8+23*, 1984-94, and it has a special power due to its combination of a foot in the past and a foot in the present.

The balance of the eighties were highly inventive as the concept of metal cut-outs unfolded. At first these were many various forms of 2-D cut-outs, drawn in black ink from life then cut from a sheet of steel or aluminum. These were quickly followed by 3-D works in aluminum.

In the nineties, Wesselmann began doing 3-D abstract paintings and that became his primary focus until 2001, when he revisited certain previously unexplored aspects of his sixties nudes, in a rather expressionistic manner. (These have not yet been exhibited). The "Sunset Nudes" then grew out of these and at the present time occupy his focus equally as much as the abstracts.

Wesselmann dislikes the term "Pop Art", primarily because it causes many art historians, curators and critics to focus excessively on subject matter and assumed sociological commentary. Their focus tends to be literary, rather than literal. Wesselmann's motivation, what drives his art, is no different than any other fine artist in history—he wants to give form to his own personal discoveries of what is beautiful and exciting to him. He views art as an ongoing and never ending experiment. Growth is the goal, and that growth is never complete—art must be in constant change. His current work, both in 3-D abstraction and new canvas nudes, continues to strongly carry this drive forward.

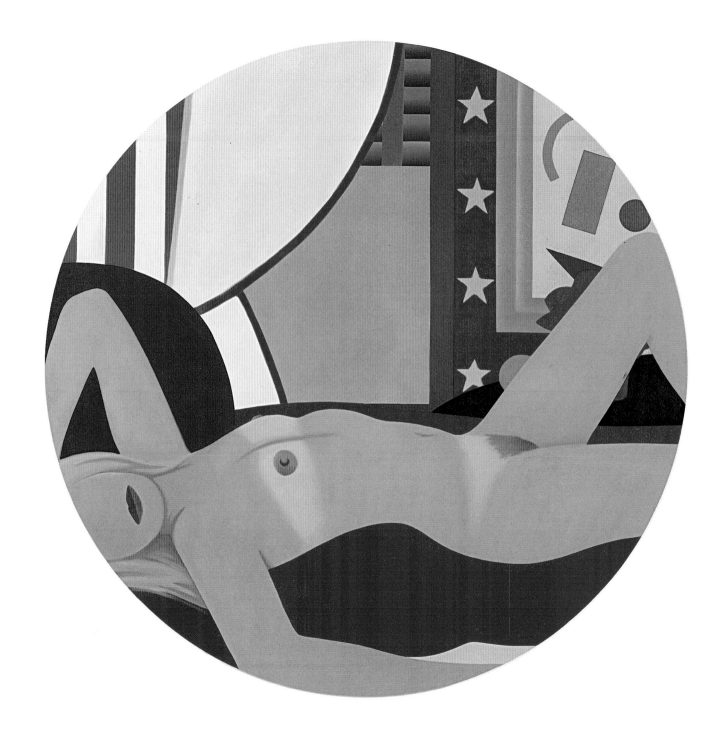

Opere / Works

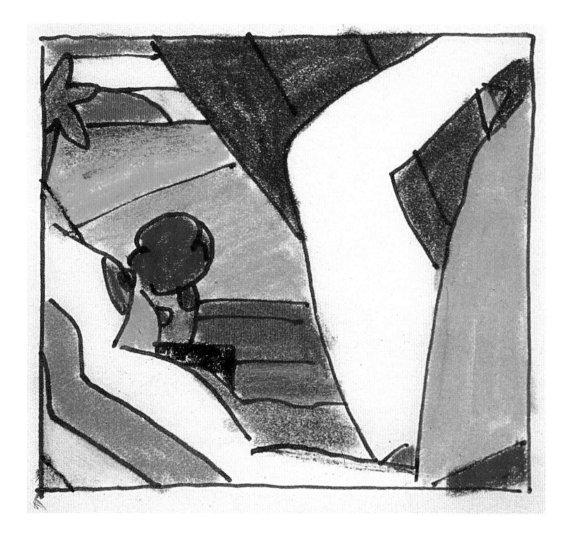

Sunset Nude, *2002*

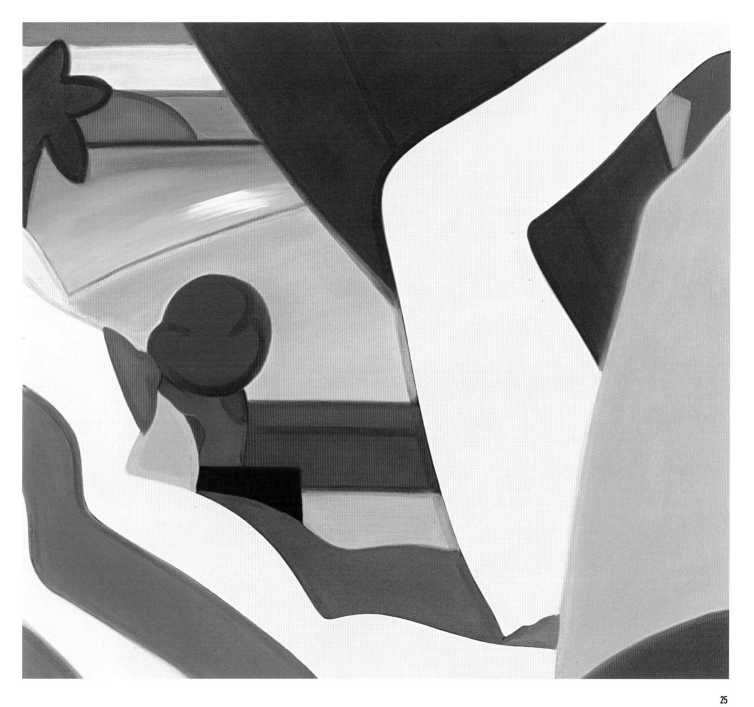

Glider, *2002*

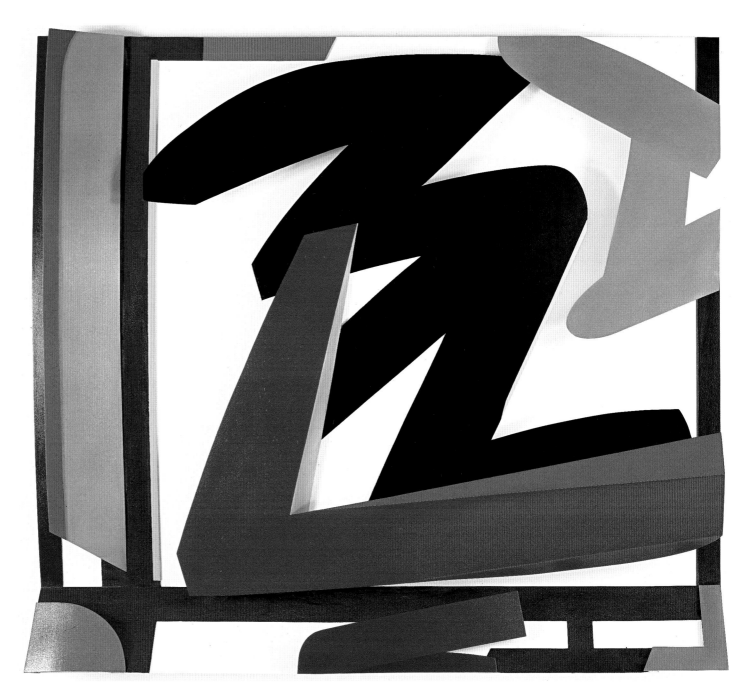

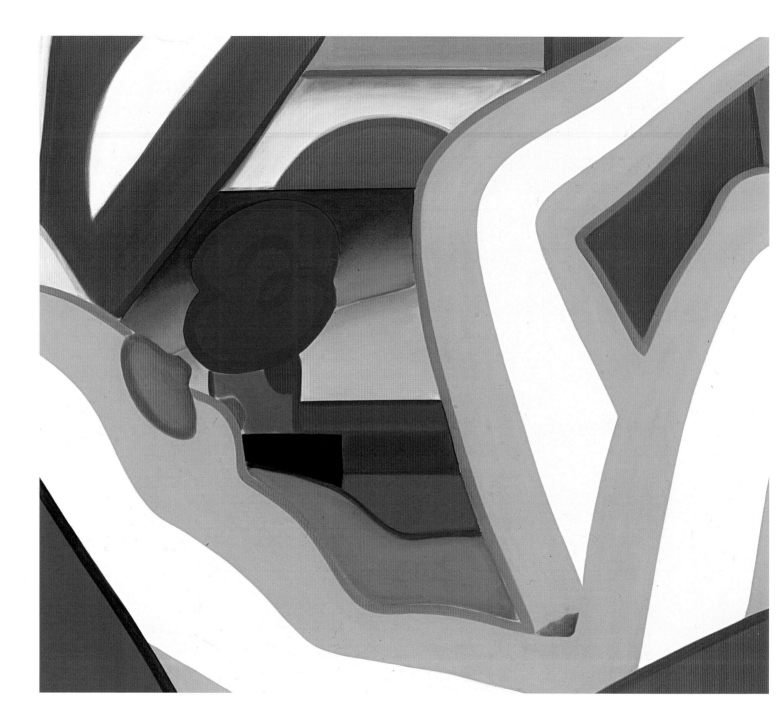

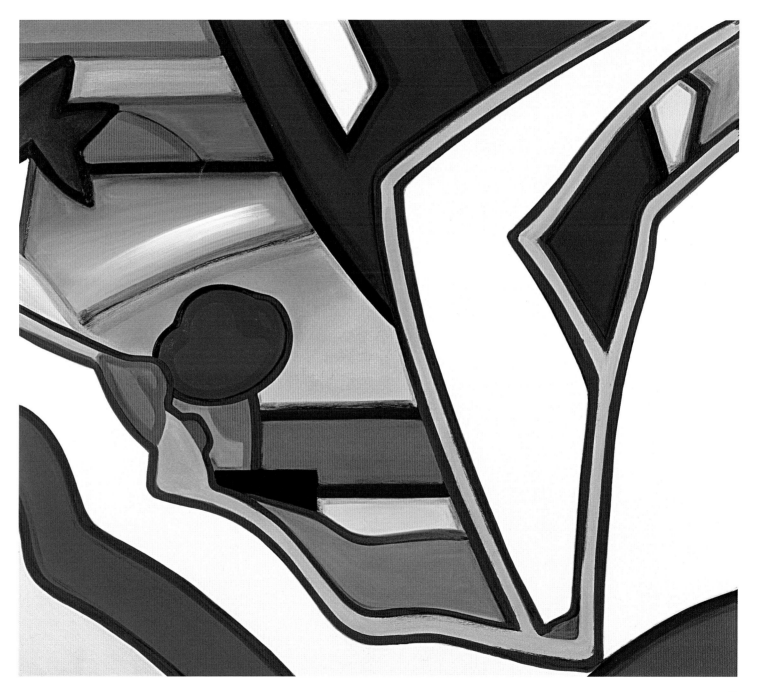

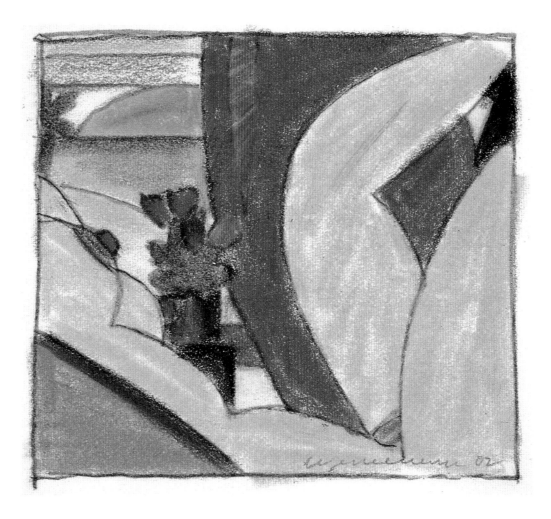

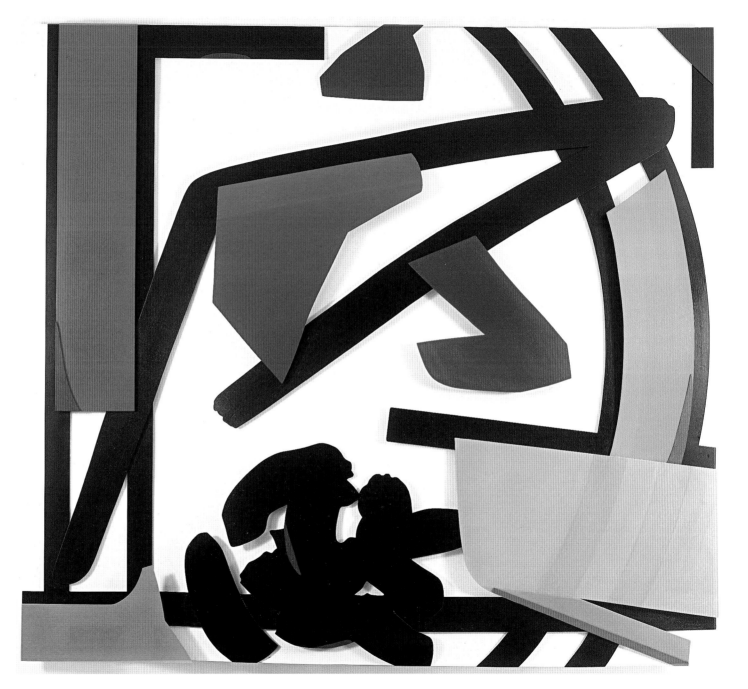

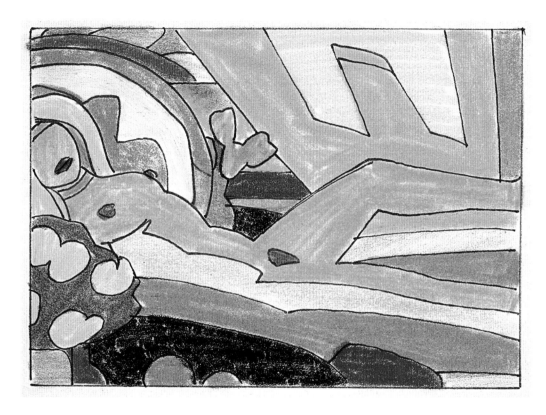

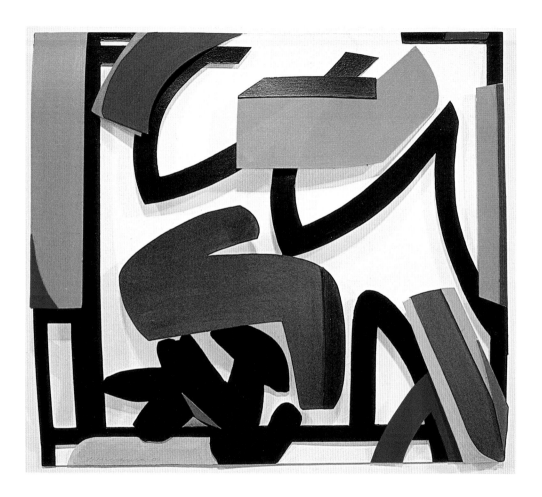

Maquette for Glider, *2001*

Maquette for Divisor, *2000*

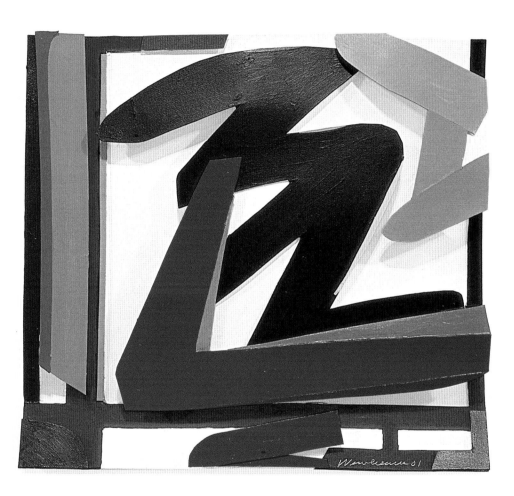

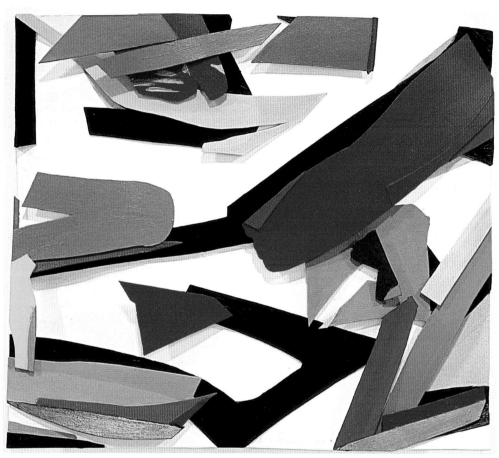

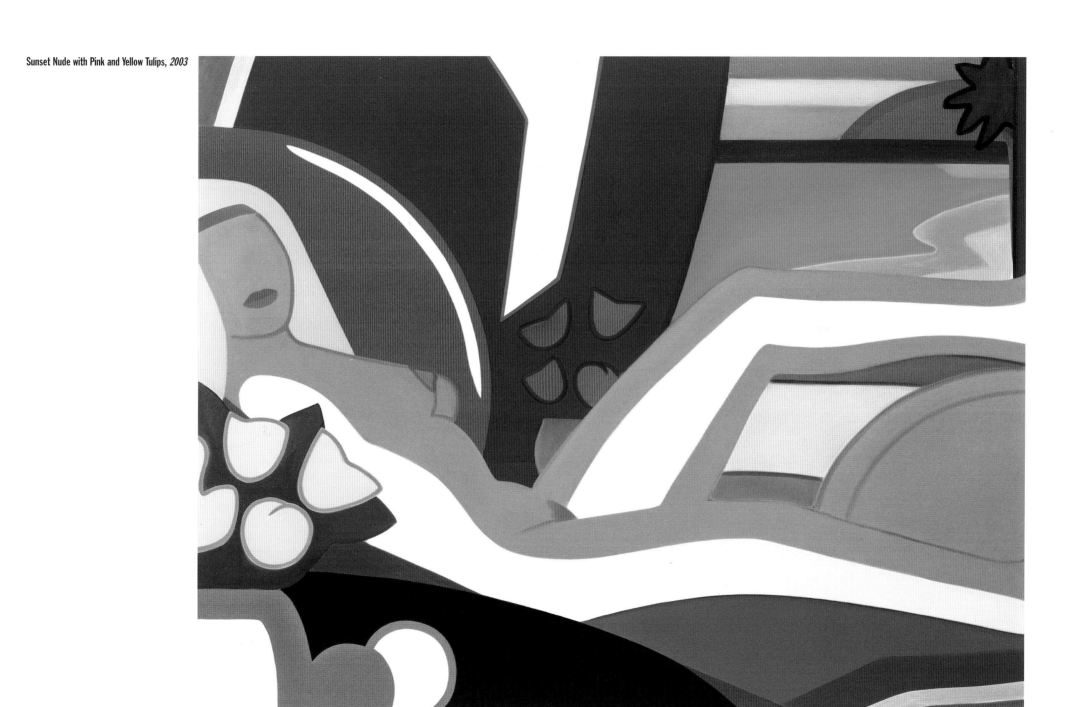

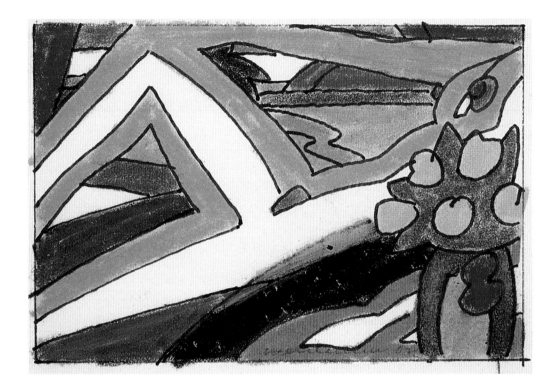

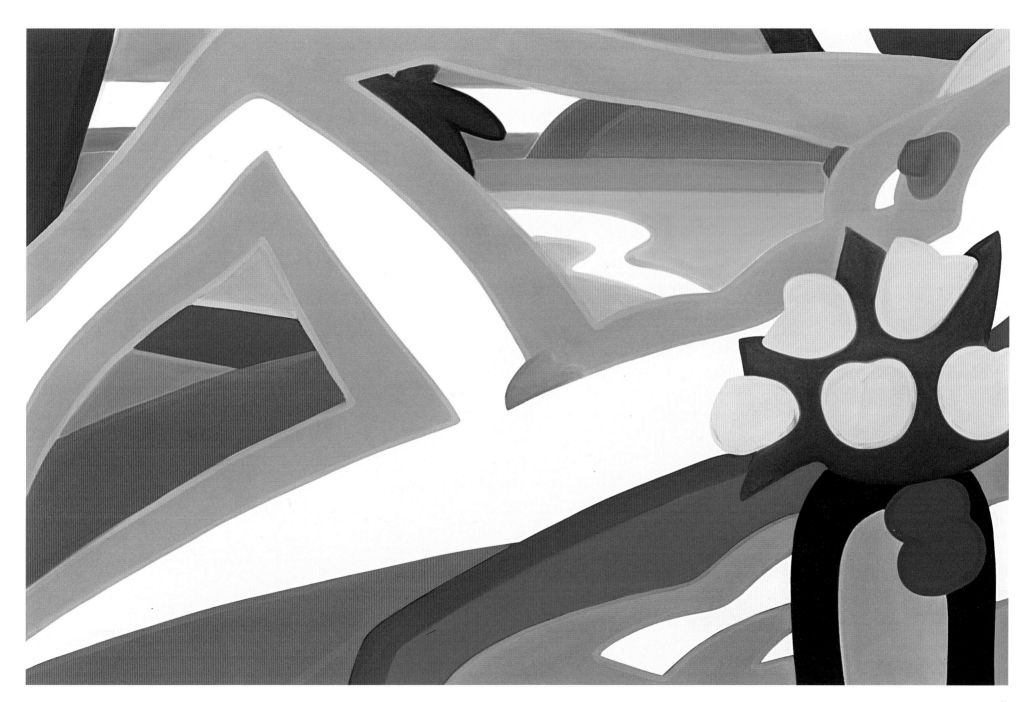

Driver, *1999-2001*

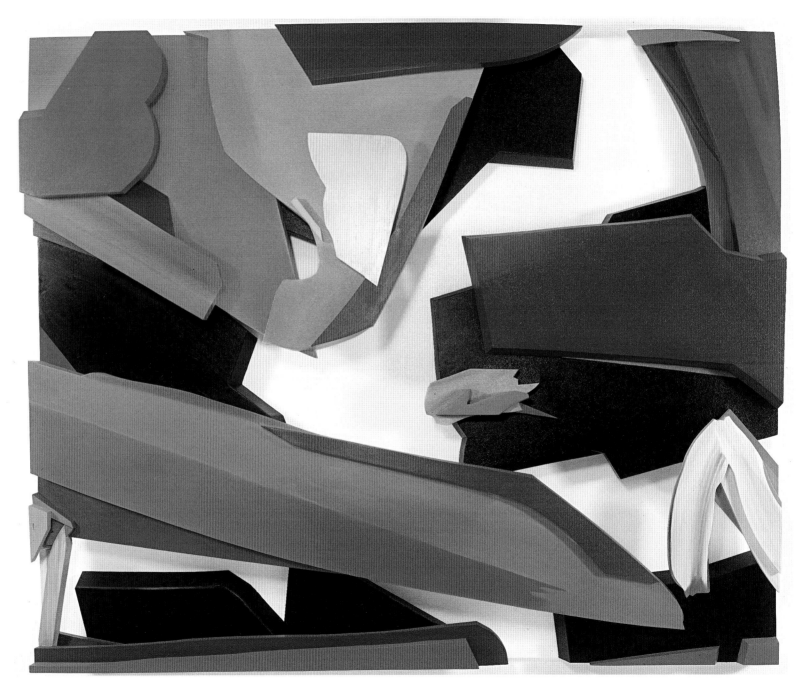

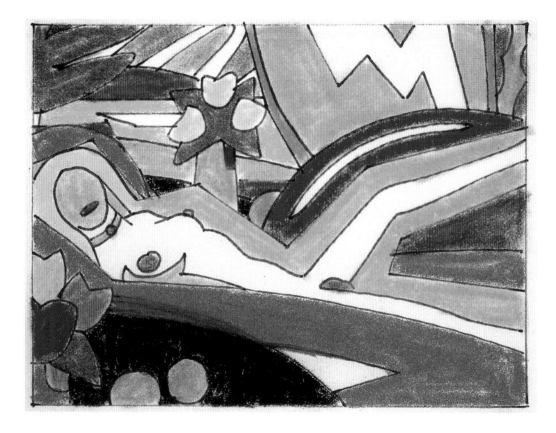

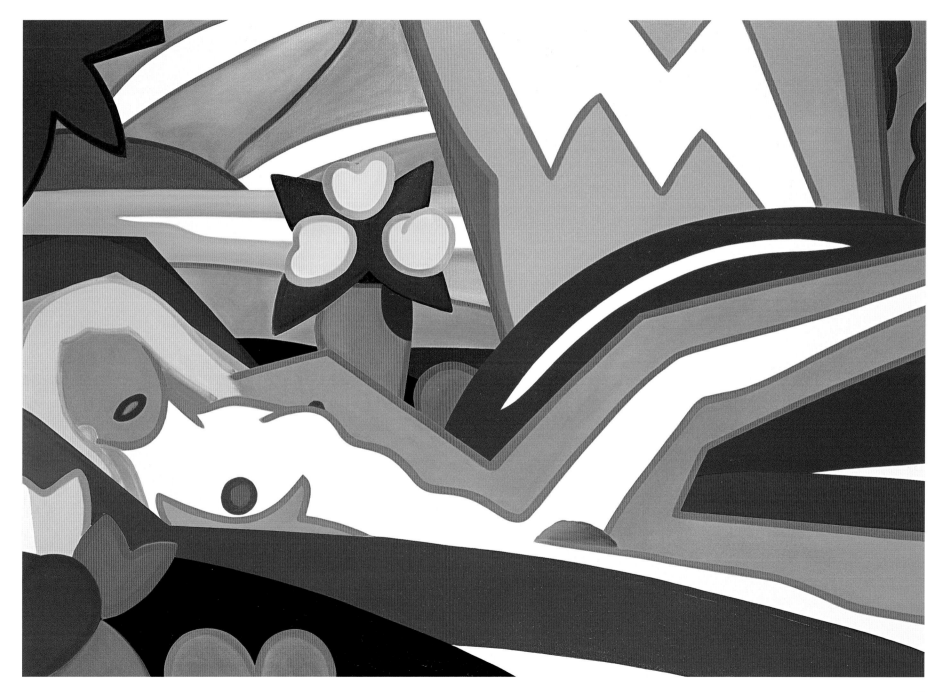

Black Strike, *2002*

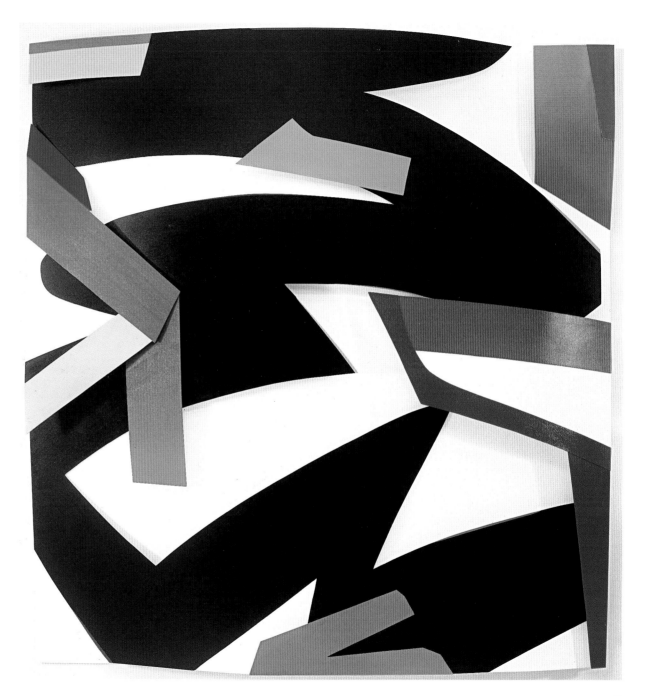

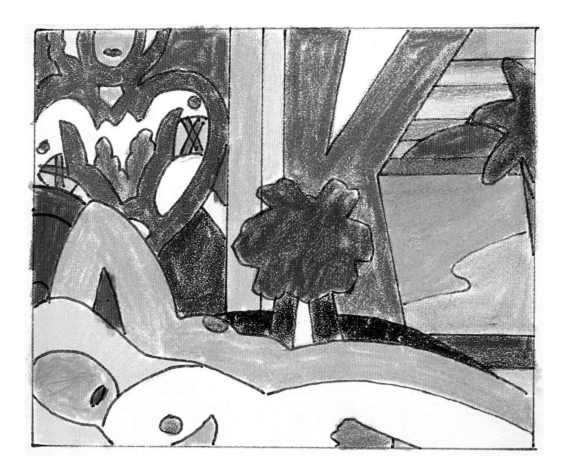

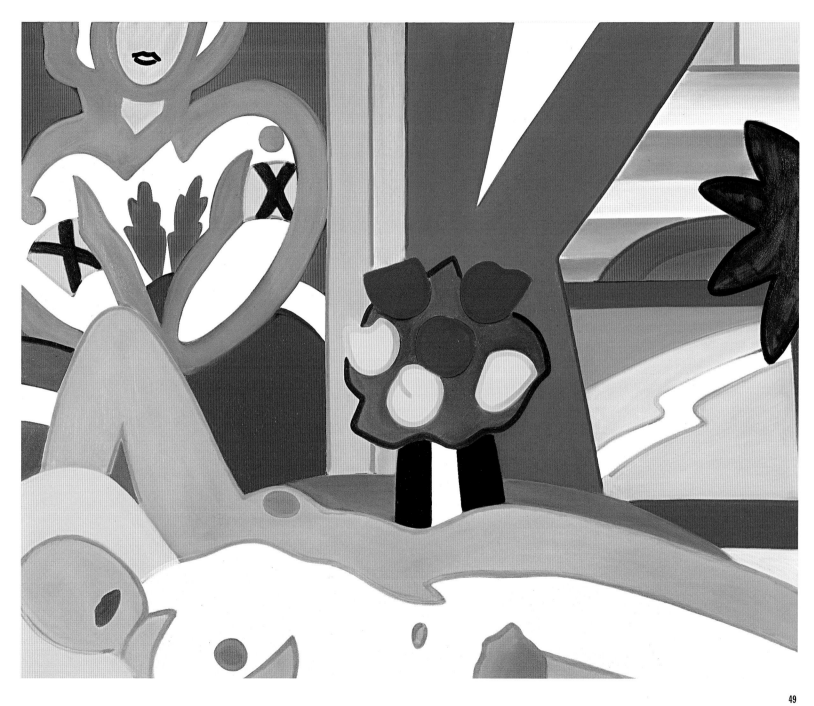

Broadway Beauty, *2002*

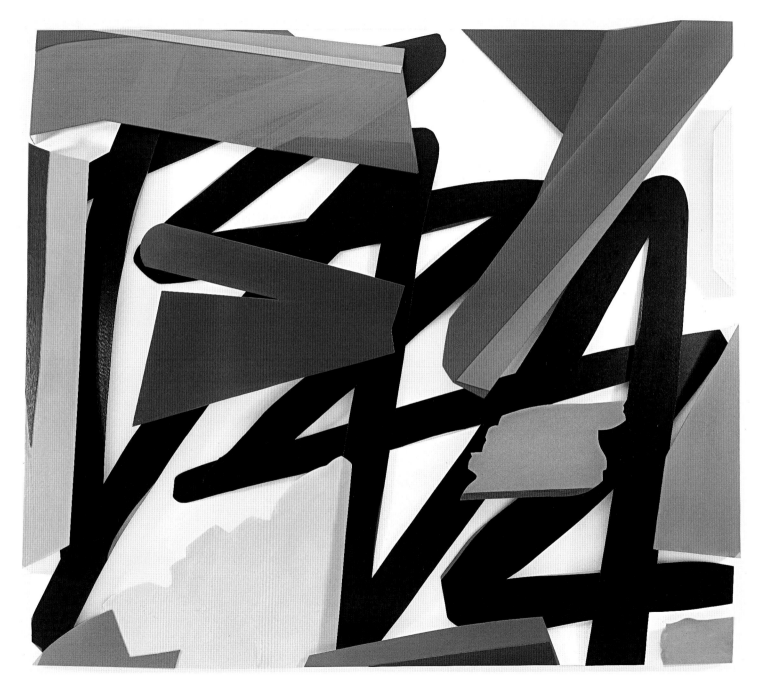

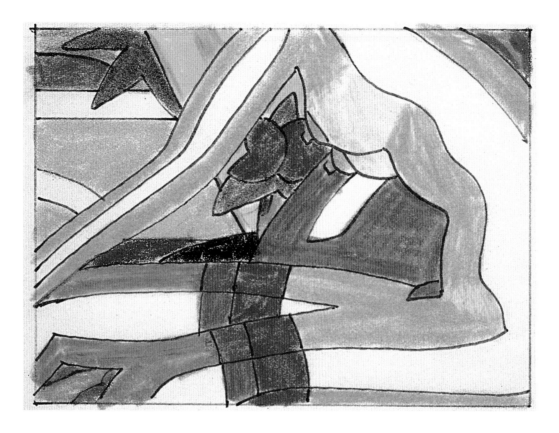

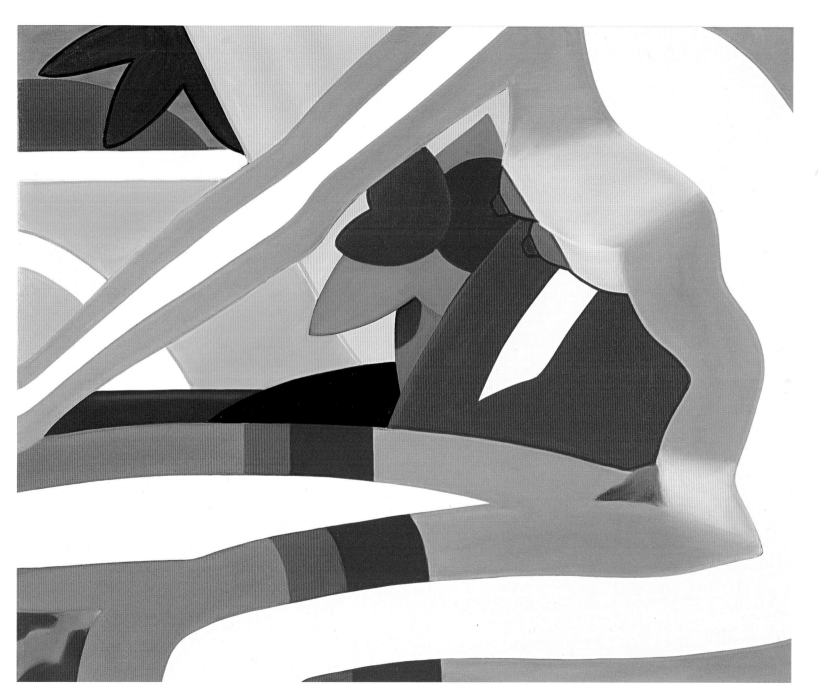

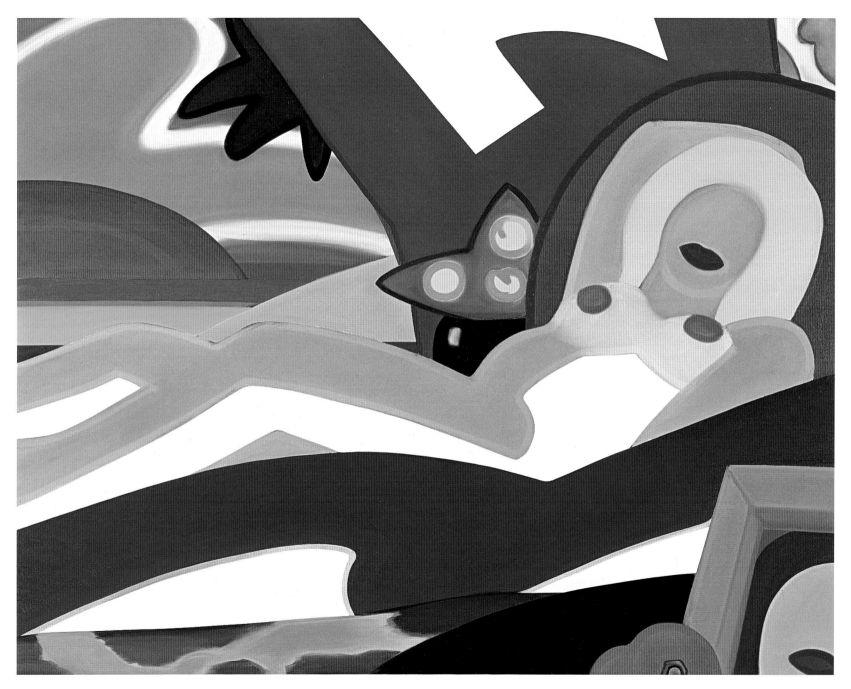

Bowery Beauty, *2001*

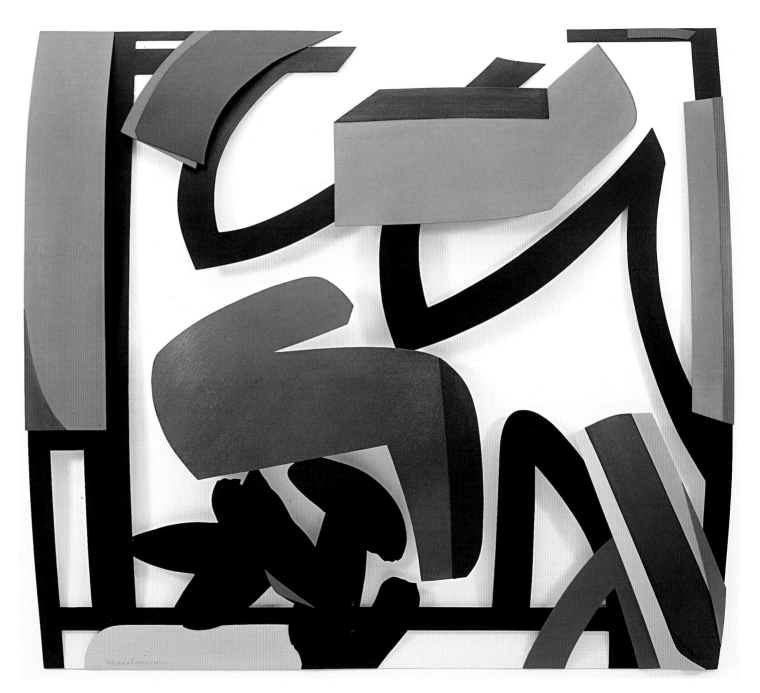

Sunset Nude (1960 Judy), *2002*

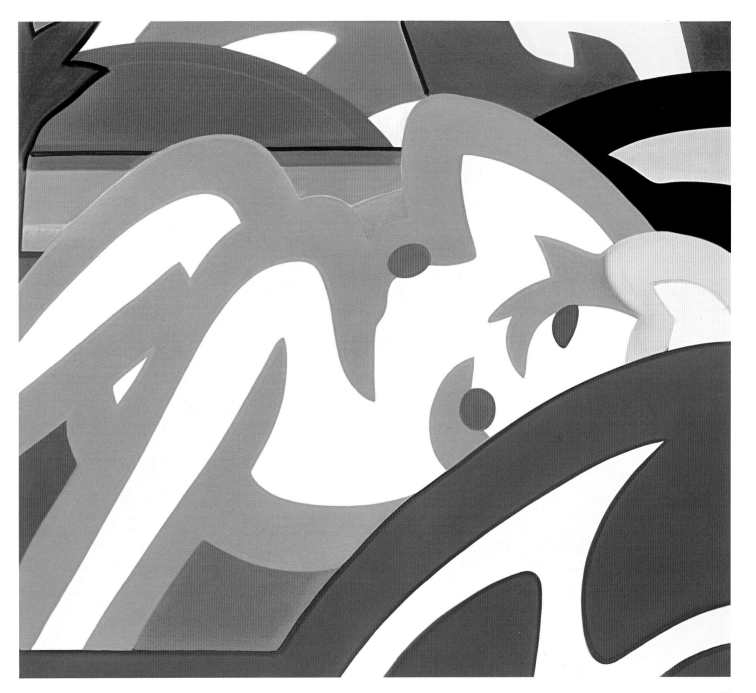

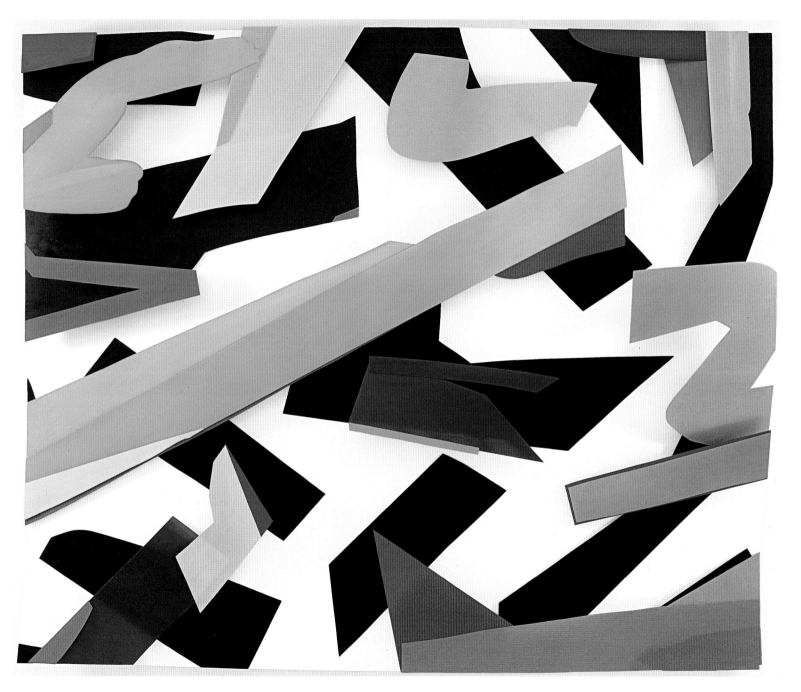

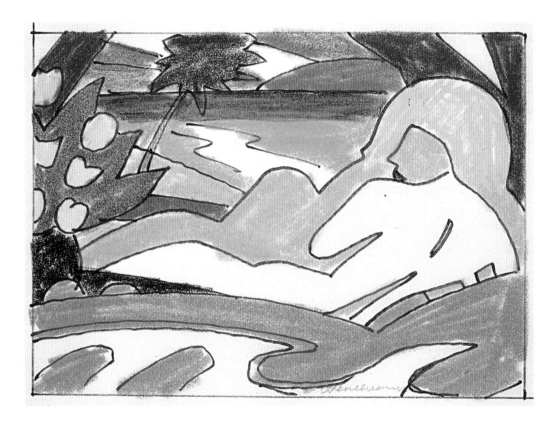

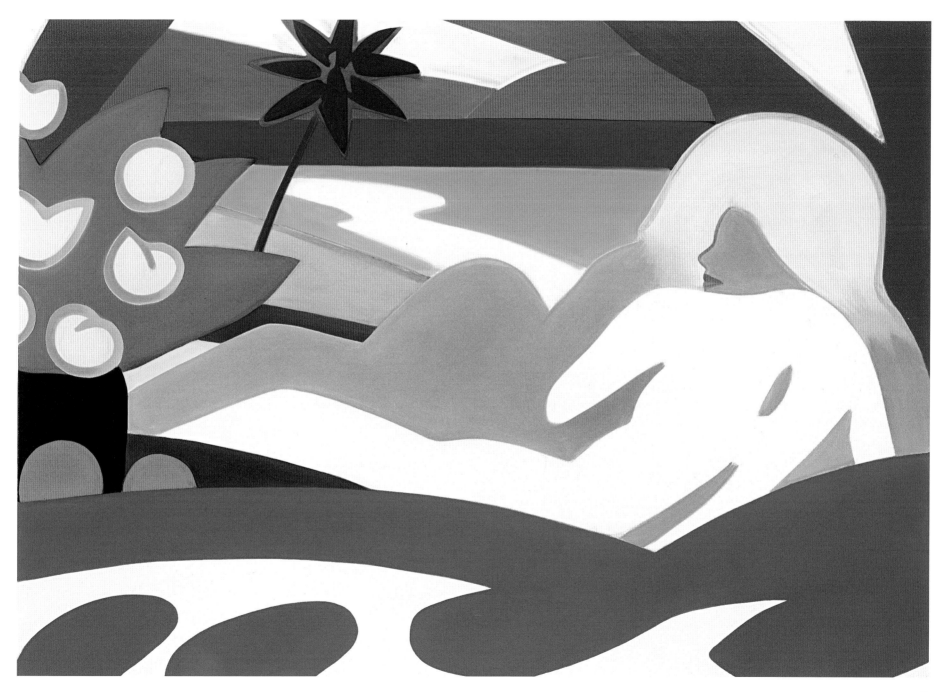

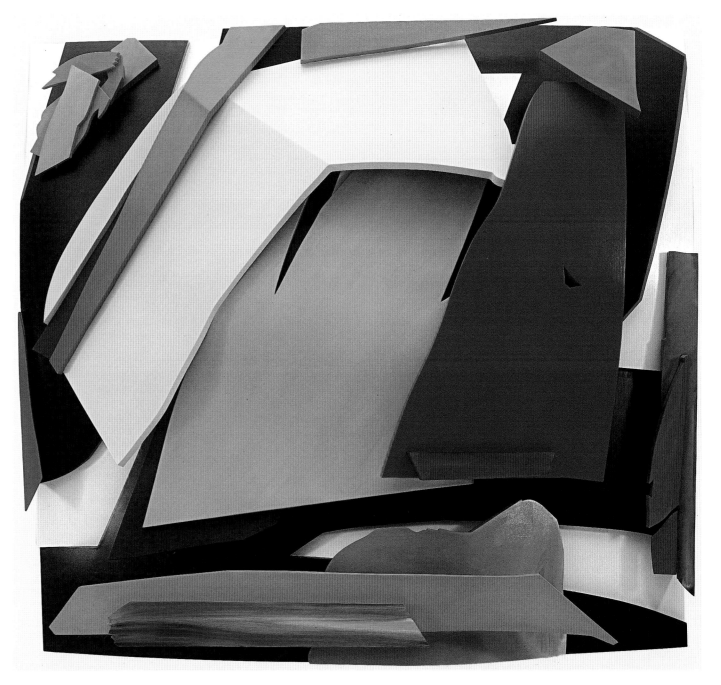

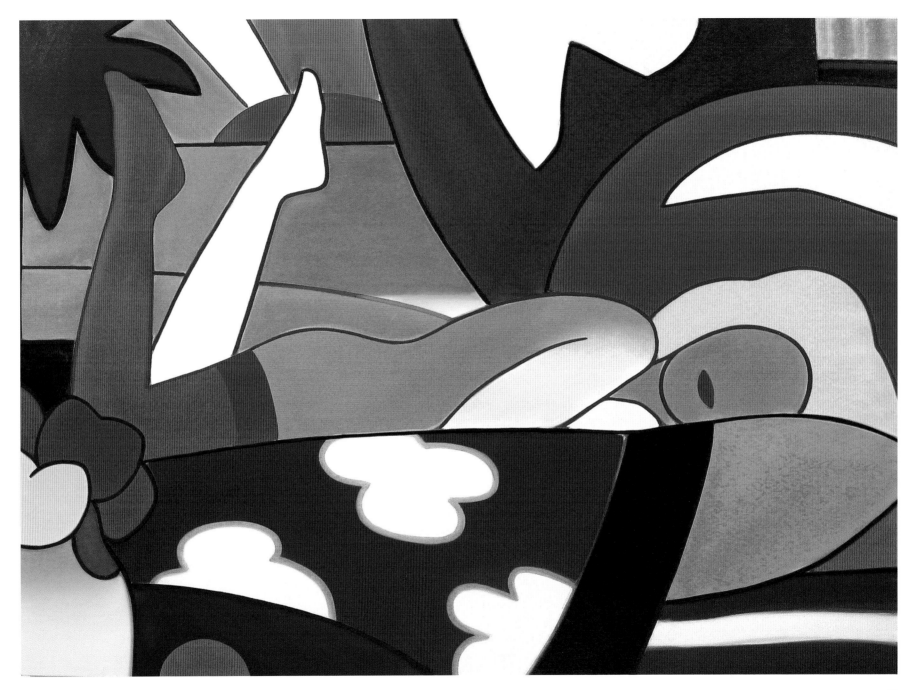

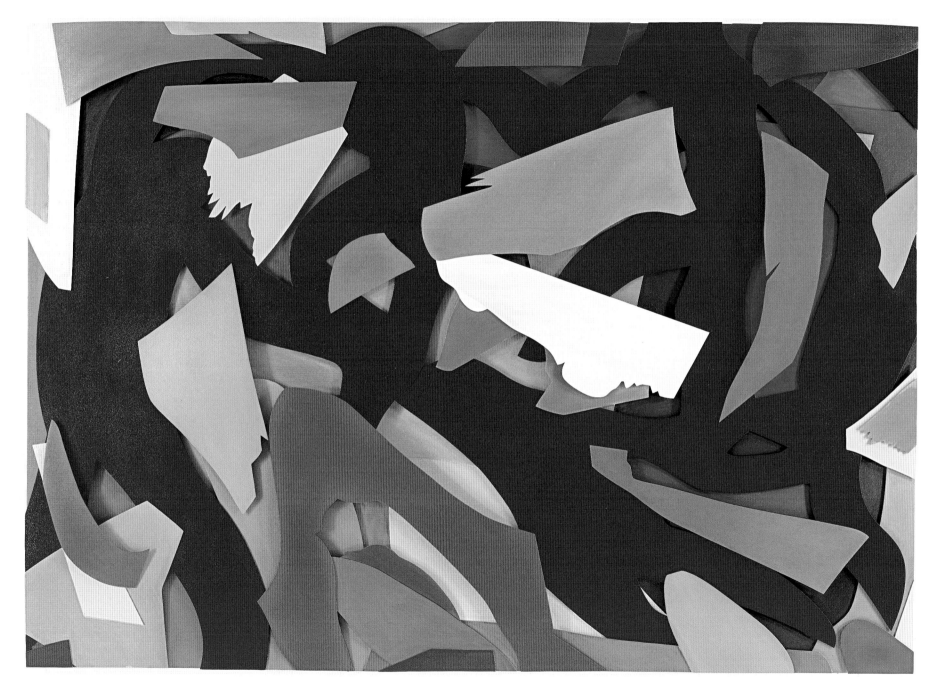

Elenco delle opere
List of Works

Study for Sunset Nude, 2002
Penna e matita colorata su cento frammenti di carta per lucidi/Pen and colored pencil on 100 rag tracing paper
cm 6x6,5 (2$^{1/4}$x2$^{1/2}$ inches)
p. 24

Sunset Nude, 2002
Olio su tela/Oil on canvas
cm 163x178 (64x70 inches)
p. 25

Glider, 2002
Olio su alluminio intagliato/Oil on cut-out aluminum
cm 203x224x28 (80x88$^{1/8}$x11 inches)
p. 27

Sunset Nude (Variation #1), 2002
Olio su tela/Oil on canvas
cm 170x193 (67x76 inches)
p. 28

Sunset Nude (Variation #2), 2002
Olio su tela/Oil on canvas
cm 168x188 (66x74 inches)
p. 29

Study for Sunset Nude (Variation #4), 2002
Penna a sfera e matita colorata su cento frammenti di carta per lucidi/Ballpoint pen and colored pencil on 100 rag tracing paper
cm 6x7 (2$^{1/4}$x2$^{3/4}$ inches)
p. 31

Manhattan Beauty, 2001
Olio su alluminio intagliato/Oil on cut-out aluminum
cm 224x246x24 (88$^{1/8}$x97x9$^{1/2}$ inches)
p. 33

Study for Sunset Nude, Yellow Tulips, Yellow Curtain, 2002
Inchiostro e matita colorata su cento frammenti di carta per lucidi/Ink and colored pencil on

100 rag tracing paper
cm 10x13 (3$^{7/8}$x5 inches)
p. 34

Sunset Nude, Yellow Tulips, Yellow Curtain, 2003
Olio su tela/Oil on canvas
cm 168x234 (66x92 inches)
p. 35

Maquette for Bowery Beauty, 2000
Liquitex su cartoncino Bristol/Liquitex on Bristol board
cm 43x47x1,6 (17x18$^{1/2}$x0$^{5/8}$ inches)
p. 36

Maquette for Glider, 2001
Liquitex su cartoncino Bristol/Liquitex on Bristol board
cm 35,5x40,5x2 (14x16x0$^{3/4}$ inches)
p. 37

Maquette for Divisor, 2000
Liquitex su cartoncino Bristol/Liquitex on Bristol board
cm 39x46x2,5 (15$^{1/2}$x18x1 inches)
p. 37

Sunset Nude with Pink and Yellow Tulips, 2003
Olio su tela/Oil on canvas
cm 188x241 (74x95 inches)
p. 39

Study for Sunset Nude (No Head), 2002
Penna a sfera e matita colorata su cento frammenti di carta per lucidi/Ballpoint pen and colored pencil on 100 rag tracing paper
cm 6x10 (2$^{1/4}$x3$^{7/8}$ inches)
p. 40

Sunset Nude (No Head), 2002
Olio su tela/Oil on canvas
cm 155x235 (61x92$^{1/2}$ inches)
p. 41

Driver, 1999-2001

Olio su alluminio intagliato/Oil on cut-out aluminum
cm 231x277x15 (91x109x6 inches)
p. 43

Study for Sunset Nude (Squared Off), 2002
Inchiostro e matita colorata su cento frammenti di carta per lucidi/Ink and colored pencil on 100 rag tracing paper
cm 8x11 (3$^{1/4}$x4$^{1/4}$ inches)
p. 44

Sunset Nude (Squared Off), 2003
Olio su tela/Oil on canvas
cm 168x235 (66x92$^{1/2}$ inches)
p. 45

Black Strike, 2002
Olio su alluminio intagliato/Oil on cut-out aluminum
cm 231x218,5x25,5 (91x86x10 inches)
p. 47

Study for Sunset Nude with Matisse, 2002
Inchiostro e matita colorata su cento frammenti di carta per lucidi/Ink and colored pencil on 100 rag tracing paper
cm 9x11 (3$^{1/2}$x4$^{1/4}$ inches)
p. 48

Sunset Nude with Matisse, 2002
Olio su tela/Oil on canvas
cm 168x203 (66x80 inches)
p. 49

Broadway Beauty, 2002
Olio su alluminio intagliato/Oil on cut-out aluminum
cm 206x231x33 (81x91x13 inches)
p. 51

Study for Sunset Nude with Red Stockings, 2002
Inchiostro e matita colorata su

cento frammenti di carta per lucidi/Ink and colored pencil on 100 rag tracing paper
cm 7,5x10,5 (3$^{1/8}$x4$^{1/8}$ inches)
p. 52

Sunset Nude with Red Stockings, 2003
Olio su tela/Oil on canvas
cm 168x203 (66x80 inches)
p. 53

Sunset Nude with Portrait, 2003
Olio su tela/Oil on canvas
cm 170x218,5 (67x86 inches)
p. 55

Bowery Beauty, 2001
Olio su alluminio intagliato/Oil on cut-out aluminum
cm 199x214,5x26,5 (78$^{1/2}$x84$^{1/2}$x10$^{1/2}$ inches)
p. 57

Study for Sunset Nude (1960 Judy), 2002
Penna e matita colorata su cento frammenti di carta per lucidi/Pen and colored pencil on 100 rag tracing paper
cm 8x9 (3$^{1/4}$x3$^{5/8}$ inches)
p. 58

Sunset Nude (1960 Judy), 2002
Olio su tela/Oil on canvas
cm 188x208 (74x82 inches)
p. 59

Dinner at the Museum of Modern Art, 2000
Olio su alluminio intagliato/Oil on cut-out aluminum
cm 249x302x33 (98x119x13 inches)
p. 61

Study for Sunset Nude (Big Scene), 2002
Penna e matita colorata su cento frammenti di carta per lucidi/Pen and colored pencil on 100 rag

Apparati / Appendix

Biografia
Biography

-

Nato a/Born in Cincinnati, Ohio,
23 febbraio/February, 1931
Formazione/Education: Hiram
College, Ohio; University of
Cincinnati, Ohio (B.A. in
Psicologia/Psychology); Art
Academy of Cincinnati, Ohio; The
Cooper Union, New York (laurea
in Arte/Graduate Certificate in Art)

Nel 1963 sposa Claire
Wesselmann; ha tre figli, Jenny,
Kate e Lane/In 1963 he married
Claire Wesselmann; he has three
children, Jenny, Kate and Lane

Vive e lavora a/Lives and works in
New York

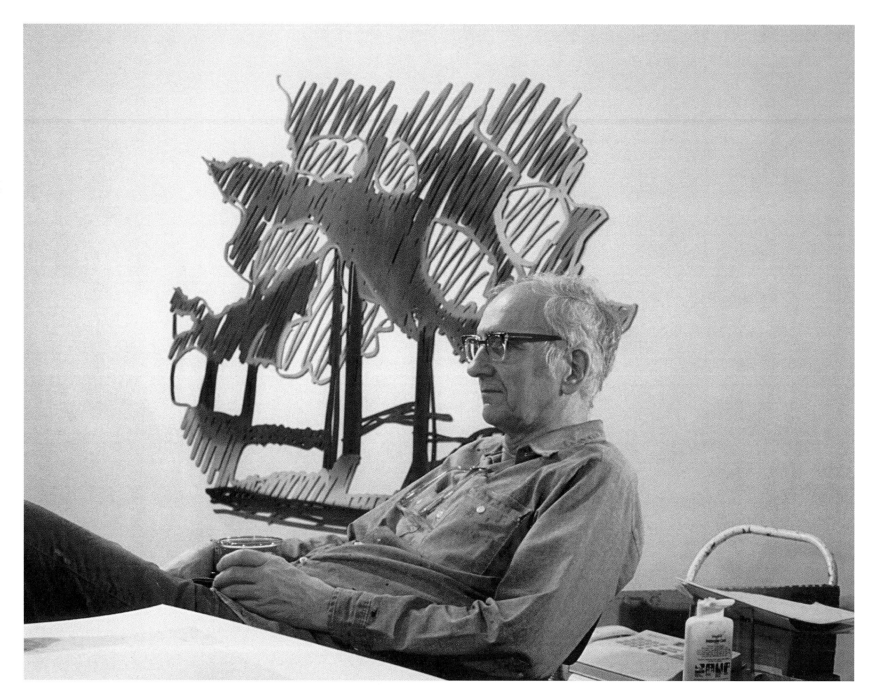

New York, *ca. 1992*

Mostre personali
Solo Exhibitions

1961
Tanager Gallery, New York.

1962
Green Gallery, New York.

1964
Green Gallery, New York.

1965
Green Gallery, New York.

1966
Sidney Janis Gallery, New York.

1967
Galerie Ileana Sonnabend, Paris, *Tom Wesselmann.*

Galleria Gian Enzo Sperone, Torino.

1968
Dayton's Gallery 12, Minneapolis, mostra itinerante/exhibition itinerary: Museum of Contemporary Art, Chicago; De Cordova Museum and Sculpture Park, Lincoln, Massachusetts.

Sidney Janis Gallery, New York, *An Exhibition of New Work by Tom Wesselmann.*

1970
Sidney Janis Gallery, New York Newport Harbor Art Museum, Balboa, California, *Early Still-Lifes 1962-1964*, mostra itinerante/ exhibition itinerary: The Nelson-Atkins Museum of Art, Kansas City; The Lincoln Art Museum, Lincoln, Massachusetts.

1971
Jack Glenn Gallery, Corona del Mar, California.

1972
Sidney Janis Gallery, New York, *Tom Wesselmann.*

Rosa Esman Gallery, New York.

Galerie Aronowitsch, Stockholm.

1973
Multiples Gallery, New York, Los Angeles.

1974
Sidney Janis Gallery, New York.

Galerie des Quatre Mouvements, Paris.
The Art Galleries, California State University, Long Beach, *Wesselmann, The Early Years: Collages 1959-1962*, mostra itinerante/exhibition itinerary: Trisolini Gallery of Ohio University, Athens; The Nelson-Atkins Museum of Art, Kansas City.

1976
Sidney Janis Gallery, New York.

1978
Institute of Contemporary Art, Boston, *Tom Wesselmann Graphics 1964-1977.*

1979
Sidney Janis Gallery, New York.

F.I.A.C. Grand Palais, Paris.

Ehrlich Gallery, New York.

Galerie Serge de Bloe, Bruxelles.

Hokin Gallery, Miami.

1980
Sidney Janis Gallery, New York, *New Sculpture & Paintings by Tom Wesselmann.*

1981
Hokin Gallery, Bay Harbor Islands, Florida.

Hokin Gallery, Chicago.

1982
Sidney Janis Gallery, New York.

Carl Solway Gallery, Cincinnati.

Margo Leavin Gallery, Los Angeles.

1983
Sidney Janis Gallery, New York, *New Work by Tom Wesselmann.*

Sander Gallery, New York.

Delahunty Gallery, Dallas.

1984
Galerie Esperanza, Montreal.

Modernism, San Francisco.

McIntosh/Drysdale Gallery, Houston.

1985
Sidney Janis Gallery, New York.

Hokin Gallery, Palm Beach.

Jeffrey Hoffeld & Co., New York.

1986
Hokin Gallery, Bay Harbor, Florida.

Gallery Quintana, Bogotá.

Galerie Joachim Becker, Cannes.

Galerie Denise René Hans Mayer, Düsseldorf, *Cut-Outs.*

OK Harris Gallery, New York.

Carl Solway Gallery, Cincinnati.

Galerie Quintana, Bogotá.

Galerie Joachim Becker, Cannes.

Galerie Denise René Hans Mayer, Düsseldorf.

1987
Sidney Janis Gallery, New York.

Queens Museum, Flushing, New York.

Galerie Esperanza, Montreal.

Galerie de France, Paris.

The Cooper Union, New York.

1988
Galerie Tokoro, Tokyo, *Wesselmann Recent Works.*

Sander Gallery Booth, Hamburg Art Fair, Hamburg.

Mayor Gallery, London.

Sidney Janis Gallery, New York.

Stein Gallery, Chicago, *Tom Wesselmann Retrospective: Graphics & Multiples*, mostra itinerante/exhibition itinerary: Cumberland Gallery, Nashville; Hokin Gallery, Palm Beach; Charles Foley Gallery, Columbus, Ohio; Nan Miller Gallery, Rochester, New York; Hara Museum of Contemporary Art, Tokyo.

1989
Blum Helman Gallery, Santa Monica, California.

Waddington Galleries Ltd., London.

Maxwell Davidson Gallery, New York.

Galerie Joachim Becker, Cannes.

1990
John Stoller Gallery, Minneapolis.

Blum Helman Gallery, Santa Monica.

Gloria Luria Gallery, Bay Harbor Islands, Florida.

Hokin Gallery, Palm Beach.

Posner Gallery, Milwaukee.

Sidney Janis Gallery, New York.

OK Harris Gallery, New York.

Studio Trisorio, Napoli.

Fay Gold Gallery, Atlanta.

Galerie Esperanza, Montreal.

Wilkey Fine Arts, Medina, Washington.

New York, 1961
Photo Jerry Goodman

New York, 1963
Photo Jerry Goodman

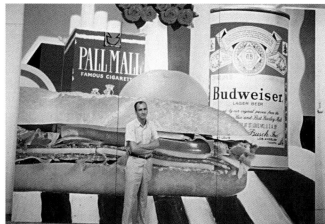

Galerie Joachim Becker, Cannes.

Colorado State University, Fort Collins, Colorado.

1991
Contemporary Arts Center, Cincinnati, *Wesselmann: Graphics/Multiples Retrospective 1964-1990.*

Edward Totah Gallery, London.

Galerie Tokoro, Tokyo.

Tasende Gallery, Chicago.

International Art Exposition, Chicago.

1992
Riva Yares Gallery, Scottsdale, Arizona, *Tom Wesselmann.*

Sidney Janis Gallery, New York, *Tom Wesselman: New Metal Paintings.*

1993
OK Harris/David Klein Gallery, Birmingham, Michigan, *Nudes, Landscape, Still Lifes.*

Foundation Veranneman, Kruishouten, Belgium, *Tom Wesselmann.*

Wassermann Gallery, München Shimbun, Isetan Museum of Art, Shinjuku, Tokyo, *Tom Wesselmann: A Retrospective Survey 1959-1992*, a cura di/organized by Sankei Japan, mostra itinerante/exhibition itinerary: Museum of Contemporary Art, Sapporo, Japan; The Museum of Modern Art, Shiga, Japan; Museum of Art, Kintetsu, Japan.

Wassermann Galerie, München, *Tom Wesselmann: New Cut-Outs and Drawings.*

1994
Cranbrook Academy of Art Museum, Bloomfield Hills, Michigan, *Larger than Life: Two Paintings by Tom Wesselmann.*

Institut für Kulturaustausch, Tübingen, *Retrospective 1959-1993*, a cura di/curated by Thomas Buchsteiner, Otto Letze, mostra itinerante/exhibition itinerary: Palais des Beaux-Arts, Bruxelles; Altes Museum, Berlin; Museum Villa Stuck, München; Kunsthal, Rotterdam; Historisches Museum der Pfalz, Speyer, Deutschland; Fondation Cartier pour l'Art Contemporain, Paris; Fundación Juan March, Madrid; Palais de la Virreina, Barcelona; Culturgest, Lisboa; Musée de l'Art Moderne, Nice.

Nikolaus Fischer Gallery, Frankfurt Gana Art Gallery, Seoul.

Didier Imbert Fine Art, Paris.

Galerie Beatrice Wassermann, München.

1995
Sidney Janis Gallery, New York.

Gallery Camino Real, Boca Raton, Florida.

1996
Sidney Janis Gallery, New York, *Tom Wesselmann Paper Maquettes.*

Fred Hoffman, Santa Monica, California, *Tom Wesselmann A Survey: 1959-1995.*

Wetterling Teo Ltd., Singapore.

Maxwell Davidson Gallery, New York, *Tom Wesselmann Lasers and Lithos.*

Sidney Janis Gallery, New York, *Tom Wesselmann Abstract Paintings.*

1997
Galerie Hans Mayer, Düsseldorf.

Galerie Benden & Klimczak, Viersen, Deutschland.

1998
Sidney Janis Gallery, New York, *Tom Wesselmann New Abstract Paintings.*

Galerie Benden & Klimczak, Viersen, Deutschland.

Michael Lord Gallery, Milwaukee.

Wetterling Gallery, Stockholm.

1999
Maxwell Davidson Gallery, New York, *Tom Wesselmann: Small Survey: Small Scale.*

Gallery Camino Real, Boca Raton, Florida, *Wesselmann Maquettes and Nude Cut-Outs.*

James Mayor Gallery, London.

Artiscope, Bruxelles, *Tom Wesselmann Nudes.*

Galerie Kaess Weiss, Stuttgart.

Maxwell Davidson Gallery, New York.

Gallery Camino Real, Boca Raton, Florida.

2000
Galerie Hans Mayer, Berlin.

Galerie Benden & Klimczak, Viersen, Deutschland, *Tom Wesselmann: Paintings and Metal Works.*

Galerie Guy Pieters, Knokke-Heist, Belgium.

Heland Wetterling Gallery, Stockholm.

JGM Galerie, Paris.

Joseph Helman Gallery, New York, *Tom Wesselmann: Blue Nudes.*

Gallery Camino Real, Boca Raton, Florida.

Cincinnati Art Gallery, Cincinnati.

Galerie Benden & Klimczak, Köln, *Tom Wesselmann: Abstract Maquettes.*

2001
Pillsbury Peters Fine Art, Dallas.

Danese Gallery, New York, *Tom*

Wesselmann: 3D Maquettes.

Editions Terminus, München.

Imago Galleries, Palm Desert, California.

2002
Buschlen Mowatt Galleries, Vancouver.

JGM Galerie, Paris, *Tom Wesselmann: Blue Nudes.*

Imago Galleries, Palm Desert, California.

Thomas Ammann Fine Arts, Basel.

Heland Wetterling Gallery, Stockholm.

2003
Gallery Camino Real, Boca Raton, Florida.

Robert Miller Gallery, New York, *Tom Wesselmann.*

University of California at Long Beach, Long Beach.

Flora Bigai Arte Moderna e Contemporanea, Venezia, *Tom Wesselmann*, mostra itinerante/exhibition itinerary: Flora Bigai Arte Moderna e Contemporanea, Pietrasanta, Lucca.

Mostre collettive
Group Exhibitions

**Nel secondo studio/In his second studio,
New York, 1963-1965
Photo Jerry Goodman**

1960
Judson Gallery, New York.

1962
Finch College Museum of Art, New York, *American Figure Painting: 1957-1962.*

Sidney Janis Gallery, New York, *New Realists.*

Museum of Modern Art, New York, *Recent Painting USA: The Figure*, mostra itinerante/exhibition itinerary: Columbus Gallery of Fine Arts, Columbus, Ohio; Colorado Springs Fine Arts Center, Colorado Springs; Atlanta Arts Association, Atlanta; City Art Museum, St. Louis; Isaac Delgado Museum, New Orleans; San Francisco Museum of Modern Art, San Francisco; Museum of Fine Arts, Houston; State University College, Oswego, New York.

Pace Gallery, New York, *Pop Art.*

1963
Albright-Knox Art Gallery, Buffalo, New York, *Mixed Media and Pop Art.*

Green Gallery, New York, *Recent Work.*

Rose Art Museum, Brandeis University, Waltham, Massachusetts, *Recent Acquisitions.*

Contemporary Arts Museum, Houston, *Pop Goes the Easel.*

Rose Art Museum, Brandeis University, Waltham, Massachusetts, *New Directions in American Painting*, mostra itinerante/exhibition itinerary: Munson-Williams-Proctor Institute, Utica, New York; Isaac Delgado Museum of Art, New Orleans; Atlanta Art Association, Atlanta; JB Speed Art Museum, Louisville, Kentucky; Art Museum, Indiana University, Bloomington;

Washington University, St. Louis; Detroit Institute of Arts, Detroit.

Oakland Art Museum, Oakland, California, *Pop Art USA.*

Des Moines Art Center, Des Moines, *Signs of the Times.*

1964
Art Institute of Chicago, *67th American Exhibition.*

Institute of Contemporary Art, London, *The Popular Image.*

Bianchini Gallery, New York, *The Supermarket.*

Carnegie Museum of Art, Carnegie Institute, Pittsburgh, *The 1964 Pittsburgh International.*

Moderna Museet, Stockholm, *American Pop Kunst.*

1965
Galerie Bruno Bischofberger, Zürich, *Pop Art.*

Fort Worth Art Center, Fort Worth, *Master Drawings.*

Milwaukee Art Center, Milwaukee, *Pop Art and the American Tradition.*

The Museum of Modern Art, New York, *Recent Acquisitions.*

Hans Neuendorf Gallery, Hamburg, *Pop Art aus USA.*

Palais des Beaux-Arts, Bruxelles, *Pop Art Nouveau Réalisme, Etc.*

Whitney Museum of American Art, New York, *Recent Acquisitions.*

Worcester Art Museum, Worcester, Massachusetts, *The New American Realism.*

Whitney Museum of American Art, New York, *Annual Exhibition of Contemporary American Painting.*

1966
The Aldrich Museum, Ridgefield,

Connecticut, *Selections from the John G. Powers Collection.*

Cincinnati Art Museum, Cincinnati, *American Painting.*

Art Gallery of Toronto, Toronto, *American Painting.*

The Museum of Modern Art, New York, *Art in the Mirror*, mostra itinerante/exhibition itinerary: Mansfield Art Guild, Mansfield, Ohio; San Francisco State College, San Francisco; Municipal Art Gallery, Los Angeles; Los Angeles Valley College, Van Nuys, California; Museum of Fine Arts, Houston; State University College, Oswego, New York.

Loeb Art Center, New York University, New York, *Contemporary Drawings.*

Sidney Janis Gallery, New York, *Erotic Art '66.*

Museum of Art, Rhode Island School of Design, Providence, *Recent Still Life.*

The Museum of Modern Art, New York, *Contemporary American Still Life*, mostra itinerante/exhibition itinerary: State University College, Oswego, New York; Wabash College, Crawfordsville, Indiana; Tech Artists Course, Texas Technological College, Lubbock; Cummer Gallery of Art, Jacksonville, Florida; San Francisco State College, San Francisco; Michigan State University, Kresge Art Center, East Lansing; Mercer State University, Macon, Georgia; University of Maryland, College Park.

Bianchini Gallery, New York, *Master Drawings: Pissaro to Lichtenstein*, mostra itinerante/exhibition itinerary: The Contemporary Arts Museum, Houston.

Jewish Museum, New York, *Environmental Paintings and Constructions.*

Albright-Knox Art Gallery, Buffalo, New York, *Contemporary Art Acquisitions 1962-1965.*

Jewish Museum, New York, *The Harry N. Abrams Family Collection.*

Galleria del Leone, Venezia, *12 Super Realists.*

1967
The Museum of Modern Art, New York, *The Sixties.*

Sidney Janis Gallery, New York, *Homage to Marilyn Monroe* (catalogo/catalogue).

Institute of Contemporary Art, Boston, *American Painting Now.*

Carnegie Institute Museum of Art, Pittsburgh, *Pittsburgh International.*

The American Federation of Arts, New York, *American Still Life Painting: 1913-1967.*

Galerie der Ricke, Köln.

São Paulo, *IXth Biennale of International Contemporary Art.*

Whitney Museum of American Art, New York, *Annual Exhibition of Painting.*

US Pavillion, Canadian World Exposition, Montreal, *Expo '67.*

1968
The Museum of Modern Art, New York, *The Sidney and Harriet Janis Collection.*

Kassel, *Documenta 4.*

The American Federation of Arts, New York, *Contemporary Drawings: Op, Pop and Other Recent Trends.*

Finch College Museum, New York, *The Dominant Woman.*

Whitney Museum of American Art, New York, *Annual Exhibition of Contemporary American Sculpture*.

1969
Vancouver Art Gallery, Vancouver, Canada, *New York 13*, mostra itinerante/exhibition itinerary: Norman MacKenzie Art Gallery, Regina, Saskatchewan, Canada; Musée d'Art Contemporain de Montreal, Montreal (catalogo/catalogue).

The Art Gallery of Ateneum, Helsinki, *Ars 69-Helsinki*.

Whitney Museum of American Art, New York, *Annual Exhibition of Recent American Painting*.

Hayward Gallery, London, *Pop Art*.

The National Collection of Fine Art, Washington D.C., *The New Vein: The Human Figure 1963-1968*.

Palais des Beaux-Arts, Bruxelles, *La nouvelle figuration américaine, peinture, sculpture, film. 1963-1968* (catalogo/catalogue).

1970
Institute of Contemporary Art, Boston, *The Highway*.

American Federation of Arts, New York, *The Drawing Society's New York Regional Drawing Exhibition*.

The Art Institute of Chicago, Chicago, *30th Annual Exhibition of the Society of Contemporary Art*.

The Art Museum, Princeton University, Princeton, New Jersey, *American Art Since 1960*.

Leo Castelli Gallery, New York, *Moratorium*.

Philadelphia Museum of Art, Philadelphia, *Art for Peace*.

Galerie Beyeler, Basel, *Basel International Art Fair*.

Contemporary Arts Center, Cincinnati, *Monumental Art*.

School of Fine & Applied Arts Centennial Exhibit, Boston University, Boston, *American Artists of the 1960's*.

Sheldon Memorial Art Gallery, University of Nebraska, Lincoln, *Selected Works from the Collection of Mrs. A.B. Sheldon*.

Sonnabend Gallery, New York, *Major Works in Black and White*.

1971
Mayfair Gallery, London, *Pop Art*.

Akron Art Institute, Akron, *Celebrate Ohio*.

Emily Lowe Gallery, Hofstra Museum, Hofstra University, Hempstead, New York, *Art Around the Automobile*.

1972
Whitney Museum of American Art, New York, *Annual Exhibition of Contemporary Painting & Scultpure*.

The Art Institute of Chicago, Chicago, *31st Annual Exhibition of the Society of Contemporary Art*.

The Museum of Modern Art, New York, *Recent Acquisitions*.

Muson-Williams-Proctor Institute, Utica, New York, *Recent Painting and Sculpture*.

Sidney Janis Gallery, New York, *Basel International Art Fair*, Basel.

1973
Whitney Museum of American Art, New York, *Contemporary American Drawings*.

New School Art Center, New York, *Erotic Art*.

San Francisco Museum of Art, San Francisco, *Works from the Richard Brown Baker Collection*.

1974
New York Cultural Center, New York, *Choice Galleries – Galleries' Choice*.

Sidney Janis Gallery, New York, *25th Anniversary Exhibition* (catalogo/catalogue).

Whitney Museum of American Art, New York, *American Pop Art*.

Delaware Art Museum, Wilmington, *Contemporary American Paintings from the Lewis Collection*.

The Art Institute of Chicago, Chicago, *71st American Exhibition*.

Allan Frumkin Gallery, New York, *1961 – American Painting in the Watershed Years*.

1975
The Museum of Modern Art, New York, *American Art Since 1945 from the Collection of the Museum of Modern Art*, mostra itinerante/exhibition itinerary: Worcester Art Museum, Worcester, Massachusetts; Toledo Museum of Art, Toledo; Denver Art Museum, Denver; Fine Arts Gallery of San Diego, San Diego, California; Dallas Museum of Fine Arts, Dallas; Joslyn Art Museum, Omaha, Nebraska; Virginia Museum of Fine Arts, Richmond; The Bronx Museum of the Arts, Bronx, New York.

M. Knoedler & Co., New York, *American Works on Paper 1945-1975, American Art Since 1945 from the Collection of the Museum of Modern Art*.

Sidney Janis Gallery, New York, *Basel International Art Fair*, Basel.

Corcoran Gallery of Art, Washington D.C., *34th Biennial of Contemporary American Painting*.

Yale University Art Gallery, New Haven, Connecticut, *Richard Brown Baker Collects* (catalogo/catalogue).

Whitney Museum of American Art, Downtown at Federal Reserve Plaza, New York, *25 Stills*.

New York Cultural Center, New York, *The Nude in American Art*.

1976
Philadelphia College of Art, Philadelphia, *Private Notations: Artists' Sketchbooks II*.

The Fine Arts Museums of San Francisco, MH de Young Memorial Museum, San Francisco, *The Great American Foot Show*.

Transworld Art, New York, *An American Portrait 1776-1976*.

The New Gallery of Contemporary Art, Cleveland, *60s: American Pop Art and Culture of the Sixties*.

The Art Galleries, California State University, Long Beach, California, *The Lyon Collection: Modern and Contemporary Works on Paper*.

Australia Council, Sidney, *Illusions of Reality*, mostra itinerante/exhibition itinerary: Australian National Gallery, Canberra; Western Australian Art Gallery, Brisbane; Art Gallery of New South Wales, Sidney; Art Gallery of South Australia, Adelaide; National Gallery of Victoria, Melbourne; Tasmanian Museum & Art Gallery, Hobart (catalogo/catalogue).

Newcomb College, Tulane University, New Orleans, *Drawing Today in New York*.

1977
Fine Arts Gallery, California State University, Los Angeles, *Miniature*.

Pushkin Museum, Moscow,

American Painting, a cura di/curated by Henry Geldzahler.

Andrew Crispo Gallery, New York, *Twelve Americans: Masters of Collage*.

The Museum of Modern Art, New York, *American Art Since 1945*.

Spencer Museum of Art, University of Kansas, Lawrence, *Artists Look at Art*.

E.A.S.I. e/and Pleiades Gallery, New York, *Tenth Street Days – Co-ops of the Fifties*.

Joslyn Art Museum, Omaha, Nebraska, *The Chosen Object – European and American Still Life*.

Museum of Contemporary Art, Los Angeles, *The Private Images: Photographs by Artists*.

Clark Institute, Williams College, Williamstown, Massachusetts, *The Dada/Surrealist Heritage*.

1978
Whitney Museum of American Art, New York, *Art About Art*.

Sidney Janis Gallery, New York, *Seven Americans*.

Alex Rosenberg Gallery, New York, *Women: From Nostalgia to Now*.

Harold Reed Gallery, New York, *Selected 20th Century American Nudes* (catalogo/catalogue).

1979
Hooks-Epstein Galleries, Houston, *Still Life*.

Palazzo Grassi, Venezia, *Pop Art*.

School of Visual Arts, New York, *Shaped Painting*.

1980
La Jolla Museum of Contemporary Art, Santa Barbara Museum of Art, Santa Barbara, California, *Seven Decades of 20th Century Art: From*

the Sidney and Harriet Janis Collection of the Museum of Modern Art and the Sidney Janis Gallery Collection (catalogo/catalogue). Harold Reed Gallery, New York, *American Self-Portraits*.

Brooklyn Museum, Brooklyn, *American Drawing in Black and White: 1970-1980*, a cura di/curated by Gene Baro.

Hope Makler Gallery, Philadelphia.

1981
Max Hutchinson Gallery, New York, *Sculptor's Drawings*.

The Maryland Institute College of Art, Baltimore, *The Human Form: Interpretations*.

The Aldrich Museum of Contemporary Art, Ridgefield, Connecticut, *New Dimensions in Drawing*.

Delaware Art Museum, Wilmington, *Be My Valentine*.

Barbara Gladstone Gallery, New York, *Summer Pleasure*.

1982
Zabriskie Gallery, New York, *Flat and Figurative: 20th Century Wall Sculpture*.

The Aldrich Museum of Contemporary Art, Ridgefield, Connecticut, *Homo Sapiens: The Many Images* (catalogo/catalogue).

Mead Art Museum, Amherst College, Amherst, Massachusetts, *When They Were Very Young*.

Semaphore Gallery, New York, *Another Look at Landscape*.

Butler Institute of America, Youngstown, Ohio, *46th National Annual Midyear Show*.

1983
Marilyn Pearl Gallery, New York.

Bucknell University, Lewisburg, Pennsylvania.

Futura Gallery, Stockholm, *Why New York*.

Linda Farris Gallery, Seattle, *Self-Portraits*.

The National Museum of Art, Osaka, *Modern Nude Paintings: 1880-1980*.

Contemporary Arts Museum, Houston, *American Still Life 1945-1983* (catalogo/catalogue).

1984
Galerie Silvia Menzel, Berlin, *Heads*.

Coe Kerr Gallery, New York, *Bathers*.

Holly Solomon Gallery, New York, *The Innovative Landscape 1984*.

Margo Leavin Gallery, Los Angeles, *American Sculpture*.

Marisa Del Re Gallery, New York, *Masters of the Sixties* (catalogo/catalogue).

Whitney Museum of American Art, New York, *BLAM! The Explosion of Pop, Minimalism & Performance 1958-1964*.

Whitney Museum of American Art, Fairfield County, Connecticut, *Autoscape – The Automobile in the American Landscape*.

Museum of Contemporary Art, Los Angeles, *Automobile & Culture*.

1985
A.R.E.A., New York, *Art*.

A.R.C.A., Marseille, *New York '85*.

McIntosh/Drysdale Gallery, Washington D.C., *Celebration 1977-1985*.

Holly Solomon Gallery, New York, *The Innovative Still Life*.

1986
Mailer Museum of Art, Lynchburg, Virginia, *75 Years of Collecting American Art Randolph-Macon Woman's College: Artists on Our Wish List*.

Fondation Cartier pour l'Art Contemporain, Paris, *The 60s*.

Vanguard Gallery, Philadelphia, *Over the Sofa*.

DiLaurenti Gallery, New York, *The Female Nude* (catalogo/catalogue).

Triennale di Milano, Milano.

Castle Gallery, New Rochelle, New York, *Pop: Then and Now*.

1987
Whitney Museum of American Art at Philip Morris, New York, *Contemporary Cut-Outs* (catalogo/catalogue).

Monte Carlo, France, *Monte Carlo Sculpture '87*.

Port of History Museum at Penn's Landing, Philadelphia, *National Sculpture Society 54th Annual Exhibition*.

Kent Fine Art, New York, *Assemblage*.

Odakyu Grand Gallery, Tokyo, *USA – UK Pop Art*, mostra itinerante/exhibition itinerary: Daimuru Museum of Art, Osaka; Sogo Museum, Yokohama.

Whitney Museum of American Art, Fairfield County, Connecticut, *Contemporary Cut-Outs: Figurative Sculpture in Two Dimensions*.

Ianetti Lanzone Gallery, San Francisco, *After Pollock: Three Decades of Diversity*.

Herter Art Gallery, University of Massachusetts at Amherst, Amherst, *Contemporary American*

Collage: 1960-1986, mostra itinerante/exhibition itinerary: The William Benton Museum of Art, University of Connecticut, Storrs; Leigh University Galleries, Bethlehem, Pennsylvania; Butler Institute of American Art, Youngstown, Ohio; State University of New York, Albany; Nevada Institute for Contemporary Art, Las Vegas (catalogo/catalogue).

1988
Biennale di Venezia, Venezia.

Art Academy of Cincinnati, Cincinnati, *10 Decades*.

Galerie 1900-2000, Paris, *Pop Art*.

1989
Sherry French Gallery, New York, *Love and Charity: The Tradition of Caritas in Contemporary Painting*.

Lafayette Park Gallery, New York, *The Still Life: A Study of Genre*.

Daniel Weinberg Gallery, Santa Monica, California, *A Decade of American Drawing: 1980-1989*.

Renee Fotouhi Gallery, New York, *Boite Alerte*.

Lang & O'Hara Gallery, New York, *Prime Works from the Secondary Market*.

1990
Tony Shafrazi Gallery, New York, *American Masters of the 60s, Early and Late Works*, a cura di/edited by Sam Hunter (catalogo/catalogue).

Hara Museum of Contemporary Art, Tokyo.

1991
Sidney Janis Gallery, New York, *Who Framed Modern Art or the Quantitative Life of Roger Rabbit*, a cura di/edited by Collins & Milazzo (catalogo/catalogue).

Whitney Museum of American Art, Downtown at Federal Reserve Plaza, New York, *Image and Likeness: Figurative Works from the Permanent Collection*.

Maxwell Davidson Gallery, New York, *The Chicago International Art Exposition*.

Tasende Gallery, La Jolla, California, *The Tokyo Art Expo, Japan*.

Tony Shafrazi Gallery, New York, *Summertime*.

James Goodman Gallery, New York, *Pop on Paper* (catalogo/catalogue).

The New Jersey Center for Visual Arts, Summit, New Jersey, *Traffic Jam*.

The Royal Academy of Arts, London, *Pop Art*, a cura di/curated by Marco Livingstone, mostra itinerante/exhibition itinerary: Museum Ludwig, Köln; Reina Sofia, Madrid; Musée des Beaux-Arts de Montreal, Montreal.

O'Hara Gallery, New York, *Modern and Contemporary Sculpture*.

1992
International Images Booth, New York e/and Tasende Gallery, La Jolla, California a/at Miami Beach Convention Center, Miami, Florida, *Art Miami '92*.

Galerie Joachim Becker, Paris, *Tom Wesselmann Drawings and Steel Drawings/Roy Lichtenstein Haystacks*.

Lingotto, Torino, *Arte Americana 1930-1970*.

Seventh Regiment Armory, New York e/and Sidney Janis Gallery, New York, *The Art Show*.

Tasende Gallery Booth, Yokohama, Japan, *The Yokohama Art Fair*.

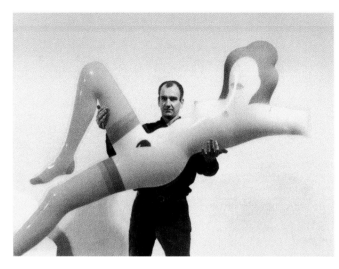

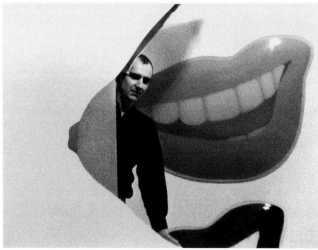

Nel terzo studio/In his third studio,
New York, 1966-1972
Photo Jerry Goodman

Carl Solway Gallery, Cincinnati,
*30th Anniversary Exhibition:
Important Paintings, Drawings,
Sculpture and Prints.*

Isetan Museum, Tokyo, *Figures of
Contemporary Sculpture, 1970-1990:
Images of Man*, mostra itinerante/
exhibition itinerary: Daimaru
Museum, Osaka; Hiroshima City
Museum of Contemporary Art,
Hiroshima.

Sidney Janis Gallery, New York, *20th
Century Masters – Works on Paper*.

Fondation Cartier pour l'Art
Contemporain, Paris, *Azure*.

1993
Sidney Janis Gallery, New York, *An
American Homage to Matisse*.

Taipei Gallery, New York, *Neither
East Nor West: Seven Contemporary
New York Artists* (catalogo/
catalogue).

Cleveland Center for
Contemporary Art, Cleveland, *25
Years A Retrospective* (catalogo/
catalogue).

1994
Sidney Janis Gallery, New York,
20th Century Masters.

Midtown Payson Galleries, New
York, *Who Needs a Bathing Suit
Anyway: Naked Men and Women in
American Art*.

Sidney Janis Gallery, New York,
Mondrian +.

Gallery Camino Real, Boca Raton,
Florida.

Sidney Janis Gallery, New York,
Brancusi to Segal.

Nassau County Museum of Art,
Roslyn Harbor, New York, *Art
After Art*.

Musée d'Art Moderne, Saint-

Étienne, France, *Art Américain. Les
Années 60-70*.

1995
ACA Galleries, New York,
American Collage.

Beth Urdang Gallery, Boston,
Summer Idylls.

Galerie Kunst Parterre GmbH,
Viersen, Deutschland, *Made in the
USA*.

Fondation Cartier pour l'Art
Contemporain, Paris.

1996
Promenade des Arts, Nice,
Chimériques Polymères.

Paris-New York-Kent Gallery, Kent,
Connecticut, *Five Contemporary
Masters and Their Assistants*.

Museo de Arte Contemporáneo de
Monterrey, Monterrey, Mexico,
Premio Marco 1996 Exhibition
(catalogo/catalogue).

1997
World Artist Tour NICAF
Pavillion, International
Contemporary Arts Festival,
Tokyo.

California Center For the Arts,
Escondido, *Table Tops: Morandi's
Still Lifes To Mapplethorpe's Flower
Studies*.

1998
The High Museum of Art, Atlanta,
*Pop Art: Selections From the Museum
of Modern Art* (catalogo/catalogue).

Tasende Gallery, West Hollywood,
La Jolla, Los Angeles.

1999
Crane Kalman Gallery, London.

Wetterling Teo Gallery, Singapur.

James Mayor Gallery, London.

2000
Newhouse Center for Contemporary
Art, Staten Island, New York.

University Art Museum, California
State University, Long Beach.

Vared Gallery, East Hampton, New
York.

Riva Yares Gallery, Scottsdale,
Arizona.

Austin Museum of Art, Austin,
The New Frontier.

2001
Sonnabend Gallery, New York.

Whitney Museum of American Art,
New York, *Pop Impact!*, mostra
itinerante/exhibition itinerary:
Cleveland Center for
Contemporary Art, Milwaukee Art
Museum, Milwaukee; Columbia
Museum of Art, Columbia, South
Carolina; Indianapolis Museum of
Art, Indianapolis; Oakland
Museum of California, Oakland.

Centre Georges Pompidou, Paris,
Les années Pop.

2002
Jack Rutberg Fine Arts, Los
Angeles.

National Academy of Design, New
York (catalogo/catalogue).

From Pop to Now, selezione da/
selection from *Sonnabend
Collection*, mostra itinerante/
exhibition itinerary: Skidmore
College, Wexner Center,
Columbus, Ohio; Milwaukee Art
Museum, Milwaukee (catalogo/
catalogue).

Collezioni pubbliche
Public Collections

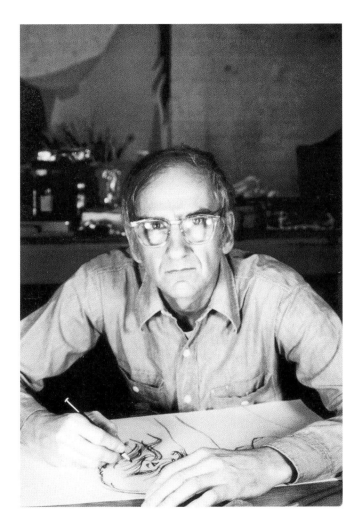

Stati Uniti/United States

Albright-Knox Art Gallery, Buffalo, New York.
Cincinnati Art Museum, Cincinnati.
Chrysler Museum, Norfolk, Virginia.
Dallas Museum of Fine Arts, Dallas.
Hirshhorn Museum & Sculpture Garden, Washington D.C.
Minneapolis Institute of Fine Arts, Minneapolis.
The Museum of Modern Art, New York.
National Museum of American Art, Smithsonian Institute, Washington D.C.
The Nelson-Atkins Museum of Art, Kansas City.
Philadelphia Museum of Art, Philadelphia.
Princeton University Art Museum, Princeton, New Jersey.
Rice University, Houston.
Rose Art Gallery, Brandeis University, Waltham, Massachusetts.
Spencer Museum of Art, University of Kansas, Lawrence.
Sidney & Francis Lewis Collection, Virginia Museum of Fine Arts, Richmond.
University of Nebraska, Lincoln.
University of Texas, Austin.
Walker Art Center, Minneapolis.
Washington University, St. Louis.
Whitney Museum of American Art, New York.
Worcester Art Museum, Worcester, Massachusetts.

Europa/Europe

Kaiser-Wilhelm Museum, Krefeld, Deutschland.
Landesmuseum, Darmstadt.
Louisiana Museum, Humlebaek, Danmark.
Musée d'Art et d'Industrie, Saint-Étienne, France.
Nasjonalgalleriet, Oslo.
National Galerie, Berlin.
Suermondt Museum, Aachen.
Wallraf-Richartz Museum, Köln.

Estremo Oriente/Far East

Hakone Open Air Museum, Hakone, Japan.
Hara Museum of Contemporary Art, Tokyo.
The Hiroshima Profectural Museum of Art, Hiroshima.
Iwaki City Museum of Modern Art, Iwaki, Japan.
Kawamura Museum of Art, Chiba, Japan.
The Museum of Modern Art, Shiga, Japan.
The Modern Art Museum, Tokushima, Japan.
Museum of Modern Art, Toyama, Japan.
Sunje Museum of Contemporary Art, Kyungju City, Korea.

Medio Oriente/Middle East

Israel Museum, Jerusalem.

Bibliografia
Bibliography

Libri e cataloghi
Books and Catalogues

1966
Tom Wesselmann (catalogo della mostra/exhibition catalogue), Galerie Ileana Sonnabend, Paris.

1968
An Exhibition of New York by Tom Wesselmann (catalogo della mostra/exhibition catalogue), Sidney Janis Gallery, New York.

Lippard, Lucy, *Eros Presumptive. Minimal Art: A Critical Anthology*, Gregory Battock, Ed. New York.

1969
Perkins, Constance M., et al., *La nouvelle figuration américaine, peinture, sculpture, film. 1963-1968/ Neue Figuration USA, Malerei, Plastik, Film. 1963-1968* (catalogo della mostra/exhibition catalogue), Palais des Beaux-Arts, Bruxelles e/and Kölnischer Kunstverein, Köln.

1972
Tom Wesselmann, Sidney Janis Gallery, New York.

1974
Tom Wesselmann, Studio Gio' Marconi, Milano.

1980
New Sculpture & Paintings by Tom Wesselmann (catalogo della mostra/exhibition catalogue), Sidney Janis Gallery, New York.

Smith, Bradley, *20th Century Masters of Erotic Art*, Crown Publishers, Inc., New York.

Wesselmann, Tom (come/as Slim Stealingworth), *Tom Wesselmann*, Abbeville Press, New York.

1983
New Work by Tom Wesselmann

(catalogo della mostra/exhibition catalogue), Sidney Janis Gallery, New York.

1984
Cummings, Paul, *Twentieth Century American Drawings. The Figure in Context*, Schneidereith & Sons, Baltimore, Maryland.

1986
Tilly, Andrew, *Erotic Drawings*, Rizzoli, New York.

1987
Sheppard, Ileen, *Tom Wesselmann/A New Approach to Drawing* (catalogo della mostra/ exhibition catalogue), Queens Museum of Art, New York.

1988
Wesselmann Recent Works (catalogo della mostra/exhibition catalogue), Galerie Tokoro, Tokyo.

1990
Livingstone, Mario, *Pop Art: A Continuing History*, Thames & Hudson, London.

Osterwold, Tilman, *Pop Art*, Benedikt Taschen Verlag, Köln.

1991
Tom Wesselmann Steel Cutouts (catalogo della mostra/exhibition catalogue), Tasende Gallery, La Jolla.

1992
Hunter, Sam, *Tom Wesselmann* (catalogo della mostra/exhibition catalogue), Miami International Art Exposition, Miami.

1993
Adams, Laurie S., *A History of Western Art*, McGraw-Hill Book Company, New York.

Contemporary Great Masters, Tom

Wesselmann, Kodansha Ltd., vol.17.

Tom Wesselmann: A Retrospective Survey 1959-1992 (catalogo della mostra/exhibition catalogue), Isetan Museum of Art, Shimbun, Tokyo.

1995
Sidney Janis Gallery, New York, (catalogo della mostra/exhibition catalogue).

Gallery Camino Real, Boca Raton, Florida (catalogo della mostra/ exhibition catalogue).

1996
Hoffman, Fred, *Tom Wesselmann: A Survey, 1959-1995* (catalogo della mostra/exhibition catalogue), Santa Monica, California.

Wetterling Teo Ltd., Singapore (catalogo della mostra/exhibition catalogue).

Tom Wesselmann Abstract Paintings (catalogo della mostra/exhibition catalogue) Sidney Janis Gallery, New York.

Townsend, Wolfe e/and Pasquine, Ruth, *Large Drawings and Objects: Structural Foundations of Clarity – Expressive Voices of the Meaningful*, Arkansas Arts Center, Little Rock, Arkansas.

1997
Galerie Hans Mayer, Düsseldorf (catalogo della mostra/exhibition catalogue).

1998
Arnason, Harvard H. e/and Prather, Marla F., *History of Modern Art*, 4th Edition, Abrams, New York.

Tom Wesselmann New Abstract Paintings (catalogo della mostra/exhibition catalogue), Sidney Janis Gallery, New York.

Umland, Anne, *Pop Art: Selections from the Museum of Modern Art*, (catalogo della mostra/exhibition catalogue), Museum of Modern Art, New York.

1999
James Mayor Gallery, London (catalogo della mostra/exhibition catalogue).

2000
Tom Wesselmann: Abstract Maquettes (catalogo della mostra/exhibition catalogue), Galerie Benden & Klimczak, Köln.

2003
Rosenblum, Robert, *Tom Wesselmann: Nudes and Abstracts* (catalogo della mostra/exhibition catalogue), Robert Miller Gallery, New York.

Tom Wesselmann (catalogo della mostra/exhibition catalogue), Flora Bigai Arte Moderna e Contemporanea, Venezia - Pietrasanta.

Periodici/Periodicals

1962

V.R., *Tom Wesselmann at Tanager*, in *Arts Magazine*, febbraio/February.

Johnston, Jill, *Tom Wesselmann at Green Gallery*, in *ARTnews*, novembre/November.

O'Doherty, Brian, *Art: "Pop" Show by Tom Wesselmann is Revisited*, in *The New York Times*, 28 novembre/November.

1963

V.R., *Tom Wesselmann at Green Gallery*, in *Arts Magazine*, gennaio/January.

Johnston, Jill, *The Artist in a Coca-Cola World*, in *The Village Voice*, 31 gennaio/January.

Geldzahler, Henry, *Symposium on Pop Art-Special Supplement*, in *Arts Magazine*, aprile/April.

"Editor's Letter." Tom Wesselmann, in *ARTnews*, vol. 62, n. 4, estate/summer.

Tom Wesselmann at Green Gallery, in *ARTnews*, novembre/November.

1964

Tom Wesselmann at Green Gallery, in *The Village Voice*, 20 febbraio/February.

Tom Wesselmann, in *Time*, 28 febbraio/February.

Tom Wesselmann at Green Gallery, in *The Village Voice*, 29 febbraio/February.

Johnston, Jill, *Tom Wesselmann at Green Gallery*, in *ARTnews*, aprile/April.

Kozloff, Max, *New York Letter*, in *Art International*, vol. 8, n. 3, aprile/April.

1965

Green, Wilder, *"Wesselmann."*

Gordon Brown. *"Art of the Underground House: A Rebuttal"*, in *Art Voices*, marzo/March.

J.B., *Wesselmann*, in *Arts Magazine*, marzo/March.

S.C., *Wesselmann*, in *ARTnews*, marzo/March.

1966

Tom Wesselmann: Artists Say, in *Art Voices*, primavera/spring.

Abramson, J.A., *Tom Wesselmann and the Gates of Horn*, in *Arts Magazine*, vol. 40, n. 7, maggio/May.

Swenson, Gene R., *The Honest Nude – Wesselmann*, in *Art and Artist*, vol. 1, n. 2, maggio/May.

Tom Wesselmann, in *The New York Times*, 14 maggio/May.

Willard, Charlotte, *In the Galleries*, in *The New York Post*, 21 maggio/May.

Margolis, David, *Wesselmann's Fancy Footwork*, in *Art Voices*, estate/summer.

Benedikt, Michael, *New York Letter*, in *Art International*, giugno/June.

Davis, Douglas M., *In a Surfacing of Erotic Art, Fun and Parody*, in *The National Observer*, 3 ottobre/October.

Canaday, John, *This Way to the Big Erotic Art Show*, in *The New York Times*, 9 ottobre/October.

Schjeldahl, Peter, *Erotic And/Or Art*, in *The Village Voice*, 13 ottobre/October.

Warner, Marina, *Tom Wesselmann: Art into Media – Media into Art*, in *Isis*, n. 1522, 2 novembre/November.

Ferrier, Jean-Louis, *Paris: Wesselmann et le Nu Américain*, in *La Quinzaine*, n. 15, 1-15 novembre/November.

1968

Tom Wesselmann: The Pleasure Painter, in *Avant Garde*, n. 5.

Images: Tom Wesselmann at Janis, in *Arts Magazine*, febbraio/February.

Kramer, Hilton, *Form, Fantasy, and the Nude*, in *The New York Times*, 11 febbraio/February.

Mellow, James R., *New York Letter*, in *Art International*, aprile/April.

The Great American Nude, in *Time Magazine*, 14 giugno/June.

1969

7 At Janis, in *Arts Magazine*, giugno/June.

Daval, Jean-Luc, *La Nouvelle Figuration Américaine*, in *Tribune de Genève*, 22 agosto/August.

Bruggeman, Leo, *Terugkier van ket beeld – in de Amerikaanse Kunst*, in *Die Nieve Gids*, Bruxelles, 25 ottobre/October.

1970

Marscherpa, Giorgio, *Avangardisti*, in *Avvenire*, 27 gennaio/January.

Arte Americana d'Oggi, in *Gazzetta di Parma*, 30 gennaio/January.

Frackman, Noel, *In the Galleries: Tom Wesselmann at Janis*, in *Arts Magazine*, aprile/April.

Gruen, John, *Galleries and Museums: Tom Wesselmann*, in *New York Magazine*, vol. 3, n. 15, 13 aprile/April.

Schjeldahl, Peter, *Pop Goes the Playmates Sister*, in *The New York Times*, 19 aprile/April.

Art: Still-Life, in *Time Magazine*, 20 aprile/April.

Campbell, Lawrence, *Reviews and Previews: Tom Wesselmann*, in *ARTnews*, vol. 69, n. 3, maggio/May.

Ratcliff, Carter, *Tom Wesselmann*, in *Art International*, numero speciale estivo/special summer issue.

G. Px, *L'Art Américaine à Genève: Richesse Créatrice et Eclatement de Tendances*, in *Feuille d'Avis de Lausanne*, 25 luglio/July.

Tom Wesselmann, in *Mizue Magazine*, n. 786, settembre/September.

1971

Denvir, Bernard, *London Letter*, in *Art International*, vol. 15/1, gennaio/January.

Coulanges, Henri, *Beauté Suave*, in *Connaisance des Arts*, n. 229, marzo/March.

Shirey, David L., *Woman: Part I*, in *Life Magazine*, 18 agosto/August.

1972

Restany, Pierre, *Le Nouveau Réalisme à la Conquête de New York*, in *Art International* (Lugano), gennaio/January.

Rodikoff, Sonya, *New Realists in New York*, in *Art International* (Lugano), gennaio/January.

Rose, Barbara, *Dada Then and Now*, in *Art International* (Lugano), gennaio/January.

Burton, Louise, *ROSC: Ireland's Autumn Art Show*, in *The Orange Disc*, vol. 20, n. 3, gennaio-febbraio/January-February.

Ratcliff, Carter, *New York Letter*, in *Art International*, vol. 17, n. 2, febbraio/February.

Canaday, John, *Only Half Bad – And That's Half Good*, in *The New York Times*, 6 febbraio/February.

Shirey, David L., *Former Avant-Garde Gallery Remembered in Hofstra Show*, in *The New York Times*, 27 febbraio/February.

De Benedetti, Carla, *The New Roman Way*, in *Vogue*, 15 aprile/April.

Kramer, Hilton, *Tom Wesselmann*, in *The New York Times*, 11 novembre/November.

Grenauer, Emily, *Arts and Artists*, in *The New York Post*, 18 novembre/November.

Reviews: Tom Wesselmann, in *Arts Magazine*, dicembre-gennaio/December-January 1973.

1973

Ratcliff, Carter, *Reviews: Tom Wesselmann*, in *Artforum*, gennaio/January.

Hughes, Robert, *Art: The Last Salon*, in *Time Magazine*, 12 febbraio/February.

Burgering, Tom, *De Kinderen Kunner er in Joutje Van*, in *Rotterdam Nieuwsblad*, giugno/June.

1974

Herrera, Hayden, *25th Anniversary Exhibition – Part II*, in *ARTnews*, vol. 72, n. 5, aprile/April.

Stealingworth, Slim, *Profile: Tom Wesselmann*, in *Gallery Guide*, maggio/May.

Perreault, John, *Art: Reading a Monumental Still Life*, in *The Village Voice*, 2 maggio/May.

Raynor, Vivien, *Wesselmann: The Mockery Has Disappeared*, in *The New York Times*, 12 maggio/May.

Hess, Tom, *Art: Wesselmann in New York Magazine*, 16 maggio/May.

Ress, Joanna, *Rusticating with Tom Wesselmann*, in *Soho Weekly News*, vol. 1, n. 48, 5 settembre/September.

Ballatore, Sandy, *Tom Wesselmann: The Early Years*, in *Artweek*, vol. 5, n. 41, 30 novembre/November.

Wilson, William, *Wesselmann – Portrait of an Artist's Blue Period*, in *Los Angeles Times*, 2 dicembre/December.

1975

Forgey, Benjamin, *Sizing Up Corcoran's Really Big Show*, in *The Washington Star*.

Sanders, Donald, *Artists Show Best Works*.

Forgey, Benjamin, *Corcoran Show is Mostly Big*, in *The Washington Star*, 21 febbraio/February.

Galano, Robert A., *Corcoran Biennial: A Crowd Pleaser*, in *Washington Post*, 22 febbraio/February.

Russell, John, *Corcoran American Art Biennale Opens*, in *The New York Times*, 5 marzo/March.

Bourdon, David, *American Painting Regains its Vital Signs*, in *The Village Voice*, vol. 20, n. 11, 17 marzo/March.

"Corcoran Makes History." *The Eagle*, in *The American University*, 1 aprile/April.

1976

Restany, Pierre, *L'Ecole de L'Erotisme*, in *Arts Loisirs*, n. 74, 28 febbraio/February.

Seiberling, Dorothy, *Real Big: An Escalation of Still Lifes*, in *New York Magazine*, 26 aprile/April.

Bourdon, David, *Eroticism Comes in Many Colors*, in *The Village Voice*, 10 maggio/May.

Karlins, N.F., *The Smoker as Sex Object*, in *East Side Express*, 27 maggio/May.

1978

Senie, Harriet, *Moodscapes*, in *New York Post*, 11 febbraio/February.

Goodson, Michael, *Wesselmann: All the Nudes Fit to Print*, in *Red Paper* (Boston), 4 giugno/June.

1979

Tom Wesselmann, in *Art/World*, 20 aprile/April-15 maggio/May.

Russell, John, *Art: Tom Wesselmann Sticks to the Same Last*, in *The New York Times*, 11 maggio/May.

Tallmer, Jerry, *Women Bursting Out All Over*, in *The New York Post*, 12 maggio/May.

Helfer, Judith, *Virtuase Technik in Neuen Arbeiten*, in *Aufbau*, 18 maggio/May.

Art Scene, in *Canal*, ottobre/October.

EXPOSITIONS F.I.A.C., in *Le Monde Dimanche*, ottobre/October.

F.I.A.C., in *L'Aurore*, ottobre/October.

Florescu, Michael, *Tom Wesselmann at Janis*, in *Art in America*, ottobre/October.

La Pagina dell'Arte, in *Bolafiarte*, ottobre/October.

Suacet, Jean, *L'Art c'est aussi un Produit*, in *Paris Match*, 26 ottobre/October.

1980

Review of Tom Wesselmann by Slim Stealingworth, in *National Arts Guide*, novembre-dicembre/November-December.

Bourdon, David, *Made in the USA*, in *Portfolio*, vol II, n. 5, novembre-dicembre/November-December.

Whitfield, Tony, *Pop Went the Wesselmann*, in *The Village Voice*, 12 novembre/November.

Glueck, Grace, *Art People*, in *The New York Times*, 14 novembre/November.

Russell, John, *Art: Shopping Around in Wesselmann's Mind*, in *The New York Times*, 21 novembre/November.

Tom Wesselmann, in *Basler Magazine*, n. 39, 27 novembre/November.

1982

Gardner, Paul, *Tom Wesselmann*, in *ARTnews*, gennaio/January.

Nel Nudo di Donna Io Batto Tiziano e Manet, in *Sommario*, marzo/March.

Fairbrother, Trevor K., *An Interview with Tom Wesselmann/Slim Stealingworth*, in *Arts Magazine*, maggio/May.

American Artist, giugno/June.

Liebman, Liz, *Review of Wesselmann Exhibition at Sidney Janis*, in *Artforum*, settembre/September.

Bourdon, David, *Contemporary Still Life Painting*, in *American Illustrated*, n. 312, novembre/November.

Wiegand, Wilfred, *Tom Wesselmann, Frankfurter Allgemeine Magazin*, novembre/November.

Meyer, Ruth, *Women, Object & Image, Dialogue*, novembre-dicembre/November-December.

1983

Stern (Hamburg), marzo/March.

1984

Johnson, Patricia, *Nudes by Wesselmann Challenge Viewer's Eye*, in *The Houston Chronicle*.

1985

Tom Wesselmann: Art People, in *ARTnews*, novembre/November.

McGill, Douglas C., *Tom Wesselmann in a New Medium*, in *The New York Times* 22 novembre/November.

Russell, John, *Tom Wesselmann*, in *The New York Times*, 13 dicembre/December.

1986

Beckers, Walter, *Interview: Tom Wesselmann*, in *Winners Magazine*, vol. 30, n. 2.

Westmann, Alberto, *Bien por fuera... mal por dentro*, in *Consigna* (Bogotá).

Tom Wesselmann en Galeria Quintana, in *Fin de Semana*, 28 febbraio/February.

Del Pop al Op, in *Semana* (Bogotá), marzo/March.

Escallon, Ana Maria, in *Arte de Hoy*, marzo/March.

Pop en Bogota, in *Gujon*, marzo/March.

Tom Wesselmann at Sidney Janis and Jeffery Hoffeld, in *Art in America*, marzo/March.

1987

Raynor, Vivien, *Art: Show of Works by Tom Wesselmann*, in *The New York Times*, 24 aprile/April.

Clark, Philippe-Evans, *Tom Wesselmann dans la tradition de l'expressionisme abstrait*, in *Art Press*, n. 114, maggio/May.

Lipson, Karin, *Lively Variations of an Artist's Themes*, in *Newsday*, 1 maggio/May.

Les femmes en metal de Wesselmann, in *Le Monde*, 23 maggio/May.

Jones, Bill, *Tom Wesselmann*, in *Flash Art*, ottobre/October.

1988

Tom Wesselmann, in *Blueprint*, luglio/July.

Feaver, William, *Arts*, in *The Observer*, 17 luglio/July.

Kent, Sarah, *On Flesh as Fast Food*, in *Tower House*, 27 luglio/July.

Auty, Giles, *Arts Exhibitions: Poporific*, in *The Spectator*, 30 luglio/July.

Godfrey, Tony, *Exhibition Reviews*, in *The Burlington Magazine*, agosto/August.

Ellman, Lucy, *Art Two-Dimensional*, in *New Statesman & Society*, 5 agosto/August.

Lubbock, Tom, *Great American Pop Show*, in *The Independent*, 9 agosto/August.

1989
Donohue, Marlena, *Tom Wesselmann*, in *The Los Angeles Times*, 27 gennaio/January.

1990
Trimarco, Angelo, *I Nudi di Wesselmann alla galleria Trisorio. Finiscono nel gelo le creature del laser*, in *L & A.*

Seggerman, Helen-Louise, *The New York Letter*, in *Tableau*, aprile/April.

Tom Wesselmann at Sidney Janis and O.K. Harris, in *Gallery Guide*, New York Preview, maggio/May.

McCarthy, Donald, *Tom Wesselmann and the Americanization of the Nude*, in *The Smithsonian Studies in American Art – National Museum of American Art*, vol. 4, n. 3-4, estate-autunno/summer-fall.

Holst, Lise, *Tom Wesselmann at Janis*, in *Art in America*, novembre/November.

Corbi, Vitaliano, *A Napoli dieci opere di Tom Wesselmann, padre della pop art. I laser nudes della rivolta. Storie di donne metalliche*, in *La Repubblica*, 8 dicembre/December.

Grassi, Gino, *Adamo contro Eva*, in *Terza Pagina* (Roma), 14 dicembre/December.

1991
Tasende Gallery Exhibits Wesselmann in Chicago and La Jolla, in *ARTFAX*, Tasende Galler, La Jolla.

Findsen, Owen, *Wesselmann Masters Female Nude Form*, in *The Cincinnati Enquirer*, 8 gennaio/January.

Pincus, Robert L., *Wesselmann's Art Loses Sly Playfulness as It Takes a New Twist*, in *San Diego Union*, 5 luglio/July.

Ollman, Leah, *Exchange Yields Another Effective Show*, in *Los Angeles Times*, 17 luglio/July.

Saville, Jonathan, *Popping Off*, in *San Diego Reader*, vol. 20, n. 30, 1 agosto/August.

What and Who was Pop – A Questionnaire, in *Modern Painters*, vol. 4, n. 2, autunno/autumn.

Dorment, Richard, *Painting that Jumps Off the Gallery Wall*, in *The Daily Telegraph/The Arts*, 13 settembre/September.

Melikian, Souren, *Pop Art: Resurecting an Old Joke*, in *International Herald Tribune*, 14-15 settembre/September.

Hickey, Dave, *La Jolla; Tom Wesselmann; Tasende*, in *ARTnews* vol. 90, n. 8, ottobre/October.

Kuspit, Donald, *On Being Boxed In*, in *Sculpture*, vol. 10, n. 6, novembre-dicembre/November-December.

Renton, Andrew, *The Pop Art Show*, in *Flash Art*, vol. 24, n. 161, novembre-dicembre/November-December.

Bellars, Peter, *Wesselmann's New Line Up*, in *Asami Evening News*, 2 novembre/November.

1992
Whiting, Cecile, *Pop Art*

Domesticated: Class and Taste in Tom Wesselmann's Collages, in *Genders n. 13* (University of Texas Press), primavera/spring.

Losel, Anja, *Pop Art: Die Alten Meister*, in *Stern*, n. 13, marzo/March.

1993
Colby, Joy Hakanson, *A Revealing Look at Tom Wesselmann's Nudes*, in *The Detroit News*, 12 febbraio/February.

1994
Turner, Elisa, *Tom Wesselmann*, in *ARTnews*, vol. 93, n. 1, gennaio/January.

Miro, Marcia, *Representational Art in a Big Way*, in *Detroit Free Press*, 23 febbraio/February.

1995
Karmel, Pepe, *Tom Wesselmann*, in *The New York Times*, maggio/May.

Stein, Jerry, *New Book Profiles Cincinnati Artist*, in *The Cincinnati Post*, 26 maggio/May.

1996
Kandel, Susan, *Surveying Phases of Wesselmann's Work*, in *Los Angeles Times*, 24 febbraio/February.

Darling, Michael, *Pop Tart; Tom Wesselmann's Tacky Erotica*, in *L.A. Reader*, vol. 18, n. 22, 8 marzo/March.

Wong, Susie, *Spontaneous Scribbles Lined with Steel*, in *The Straits Times*, 13 aprile/April.

Clothier, Peter, *Tom Wesselmann*, in *ARTnews*, maggio/May.

Pagel, David, *Tom Wesselmann*, in *Art Issues*, n. 43, estate/summer.

Glueck, Grace, *Tom Wesselmann, Abstract Metal Paintings*, in *The*

New York Times, 4 ottobre/October.

Greben, Deidre Stein, *Tom Wesselmann*, in *ARTnews*, vol. 95, n. 11, dicembre/December.

1997
Katz, Vincent, *Tom Wesselmann at Sidney Janis*, in *Art in America*, gennaio/January.

1998
Carlos, Isabel, *Pop 60s*, in *Flash Art*. *Tom Wesselmann*, in *The New Yorker*, 15 giugno/June.

2000
A Postwar Survey, Semi-Wild at Heart, in *The New York Times*, 29 settembre/September.

Tom Wesselmann: Blue Nudes, in *The New York Times*, 17 novembre/November.

Tom Wesselmann, in *The New Yorker*, 20 novembre/November.

2001
Tom Wesselmann at Joseph Helman, in *Art in America*.

Blue Nudes, Tom Wesselmann, Galerie JGM, in *The Art Newspaper*, n. 123, marzo/March.

Gleuck, Grace, *A Collector's Collector Whose Works Went Pop*, in *The New York Times*, 4 maggio/May.

John Baldessari, Jeff Koons, and Tom Wesselmann, in *The New York Times*, 22 giugno/June.

Johnson, Ken, *John Baldessari, Jeff Koons, Tom Wesselmann*, in *The New York Times*, 6 luglio/July.

Tom Wesselmann, Nude with Picasso, in *Art on Paper*, settembre-ottobre/September-October.

Richard Serra/Tom Wesselmann, in *The New Yorker*, 3 settembre/September.

2002
Vom geltenden Verlauf des Handler-Sammler-Gesprachs, in *Basler Zeitung*, 12 giugno/June.

Per saperne di più su Charta
ed essere sempre aggiornato
sulle novità, entra in

To find out more about Charta,
and to learn about our most recent
publications, visit

www.chartaartbooks.it

Finito di stampare nel maggio 2003
da Grafiche Antiga, Cornuda, Treviso
per conto di Edizioni Charta

O 50525727
S 00001035
TOM WESSELMANN
1°EDIZIONE

DANILO
ECCHER

EDIZIONI
CHARTA